IMAGES
of America

SANTA ANA
1940–2007

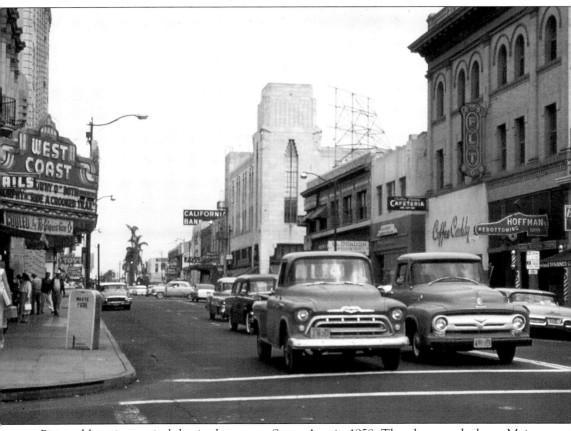

Pictured here is a typical day in downtown Santa Ana in 1958. The photograph shows Main Street at Third Street, looking north. On the left-hand side is the West Coast Theater, located at 308 North Main Street and originally known as the Walker Theater. On the right-hand side is the Oddfellows Building, and located at the far right is the art deco–styled Montgomery Ward Building. (Courtesy of Rob Richardson.)

ON THE COVER: A schoolgirl poses outside the Santa Ana Gardens Branch Library in the west end of town in 1957. (Courtesy of the Orange County Archives.)

IMAGES of America

SANTA ANA 1940–2007

Roberta A. Reed and
the Santa Ana Historical Preservation Society

Copyright © 2008 by Roberta A. Reed and the Santa Ana Historical Preservation Society
ISBN 978-0-7385-5834-9

Published by Arcadia Publishing
Charleston, South Carolina

Printed in the United States of America

Library of Congress Catalog Card Number: 2007943436

For all general information contact Arcadia Publishing at:
Telephone 843-853-2070
Fax 843-853-0044
E-mail sales@arcadiapublishing.com
For customer service and orders:
Toll-Free 1-888-313-2665

Visit us on the Internet at www.arcadiapublishing.com

This book is dedicated to the memory of my father, Bob Runnells (1929–2005). During the course of his 64 years of residence in Santa Ana, he experienced many of the memories contained in this book firsthand. He continues to live on in our hearts and memories, and the labor of love that was created in this book is dedicated to his memory and to the stories he told about Santa Ana.

Contents

Acknowledgments		6
Introduction		7
1.	1940–1949	9
2.	1950–1959	23
3.	1960–1969	59
4.	1970–1979	87
5.	1980–2007	111

Acknowledgments

There are many people without whom this book would not have been possible. First of all is my husband, Nathan, who has patiently put up with collecting, scanning, writing, and all the things that go into producing a book of this sort, even if it sometimes meant missed dinners, undone laundry, and a grumpy wife. He was also my "media expert" for this endeavor.

I would also like to thank everyone who searched out their collections and graciously loaned and provided photographs for inclusion in this book: Phil Brigandi and Chris Jepsen at the Orange County Archives; the Santa Ana Public Library History Room; Hally Sobeleske and the City of Santa Ana Planning Department; Mary Calderwood and the Santa Ana Police Department; Marshall Duell and the Old Orange County Courthouse Museum for allowing us to use photographs from the wonderful Robert Geivet Collection; County of Orange, Resources and Development Management Department; Randy and Sherry Williams; Nancy Basler Bjorklund; Bill Woodward; Mike and Tricia Macres; Jeff and Ann Dickman; Glenn and Julie Stroud; Bill Twist; Mary Garcia; Delores Martinez Grajeda; Sonny Granados; and Guy Ball. So many people contributed and offered suggestions; if I have missed anyone, I sincerely apologize. A special acknowledgment is due to Rob Richardson, who probably has the most complete and amazing collection of historic Santa Ana photographs owned privately, and he shared freely. I am also proud to be able to include photographs from the collection of my father, Bob Runnells. After his passing, we found a collection of negatives that we did not know existed, which included some wonderful Santa Ana photographs we are now able to share with you.

Special thanks go to Rob Richardson, Phil Brigandi, and Chris Jepsen, who graciously helped provide information and research for a countless number of these photographs and helped steer me back in the right direction when I tried to change Santa Ana history unintentionally!

I would also like to thank Guy Ball, veteran Arcadia author and Santa Ana Historical Preservation Society (SAHPS) treasurer, for his advice and support along the way; Wayne Curl, SAHPS board member, for pointing me toward many of these photograph collections; and Alison Young, SAHPS president, for her suggestions and advice.

Lastly, I would like to thank everyone who has a love for Santa Ana and its history. Without you, there would be no reason for this book to exist. Enjoy!

INTRODUCTION

On October 27, 1869, Jacob Ross sold William Spurgeon and Ward Bradford 74.25 acres of land. Spurgeon's one main purpose for this land was to build a town on it.

It is probably safe to assume that none of these men ever envisioned the town that those acres would eventually become. Back then, the mustard grass was so thick and high that Spurgeon had to climb a tree to survey the "town" he had purchased. He laid out his town and constructed a store, and settlers began to flock to the area. By the mid-1880s, Santa Ana was home to about 2,000 people. Some 60 years later, it had grown to about 32,000 residents and 10.5 square miles, or about 6,700 acres.

The 1940s began an age of change for the country, and Santa Ana was no exception. The year 1941 brought Pearl Harbor, and the country entered into World War II. This affected Santa Ana in many ways: local men and boys off to war, some never to return; the exodus of many residents because of the Japanese internment; and when the war was over, the shifting from an agricultural community to an industrial-based community, including an influx of population once military personnel stationed in the area decided that Southern California was indeed a paradise where they wanted to make their home.

With industry came development, and with development came people. And to accommodate all of this, there was a building boom in all areas—residential, commercial, industrial, and infrastructure. All of this development vastly changed the face of the city of Santa Ana forever.

Currently Santa Ana has over 350,000 residents and covers just over 27 square miles. Spurgeon and the other town fathers likely never in their wildest dreams imagined this phenomenal growth, most of it in the last half of the city's existence. It is that time that this book chronicles, and the changes from decade to decade are striking. These changes can be seen in the infrastructure, in some of the architecture in the city, the technology of the time, and even in our culture. Santa Ana of 2007 is much more culturally diverse than Santa Ana of 1940, but at the same time, the cultures are much more integrated in 2007 than in 1940, as this photographic history of the little town that grew into a big city portrays.

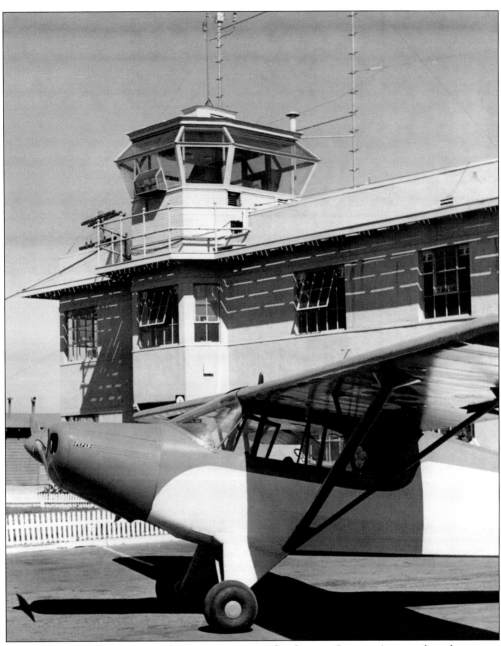

A small aircraft is parked near the airport tower at the Orange County Airport, later known as John Wayne Airport, in the 1950s. Although Arizona-based Bonanza Airlines provided the first commercial air flight from Orange County Airport, with daily service to Los Angeles, San Diego, Yuma–El Centro, and Phoenix, by far the majority of airport traffic was small private aircraft, which in those days was parked outside on pavement in "airplane parking lots." The administration building was built when the airport opened in 1941, but the airport was quickly taken over by the military during World War II. (Courtesy of the Orange County Archives.)

One
1940–1949

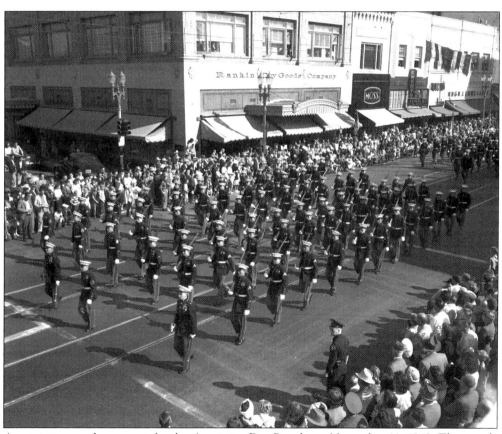

A patriotic crowd turns out for the Armistice Day Parade on November 11, 1948. The parade was routed down Fourth Street past Rankin Dry Goods Store. Armistice Day, which celebrated the end of World War I, was changed to Veterans Day in 1954. (Courtesy of the Robert Geivet Collection, Old Courthouse Museum.)

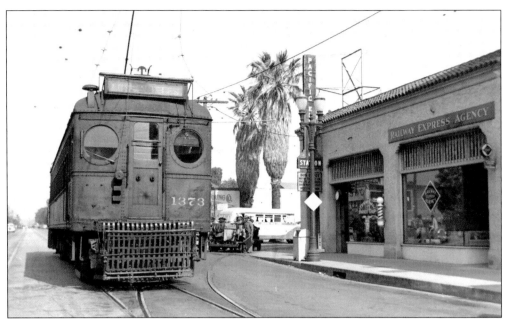

The Pacific Electric (PE) passenger and freight depot was located at 426 East Fourth Street. The PE trolley shown in this photograph would have arrived from Los Angeles and continued eastbound on Fourth Street. Passenger service on the Santa Ana line ended in 1950, and freight operations were taken over by Southern Pacific Railroad. The building was demolished in 1986. (Courtesy of Rob Richardson.)

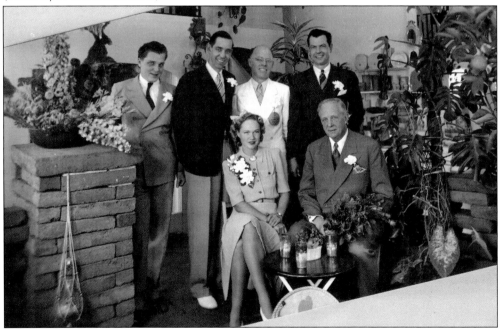

Officers of the Santa Ana Junior Chamber of Commerce are pictured with California governor Culbert Olson in the early 1940s. From left to right are (seated) the Orange Queen and Governor Olson; (standing) Albert Macres, unidentified, Bill Heins, and Herb Hill. The photograph was taken inside Macres Florists. (Courtesy of Michael and Tricia Macres.)

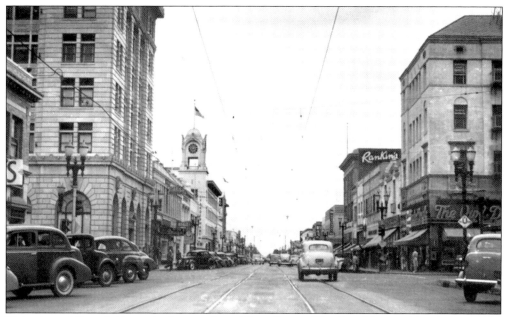

This view of Fourth Street looks west from Main Street. The First National Bank, later First Western Bank, is on the left, and the Spurgeon Clock Tower is shown on the far left. On the far right is Rankin Dry Goods. Note the wires and tracks in the middle of the road; these were for the Pacific Electric rail cars. It is also interesting to note that there is no traffic signal at this now very busy intersection. (Courtesy of the Orange County Archives.)

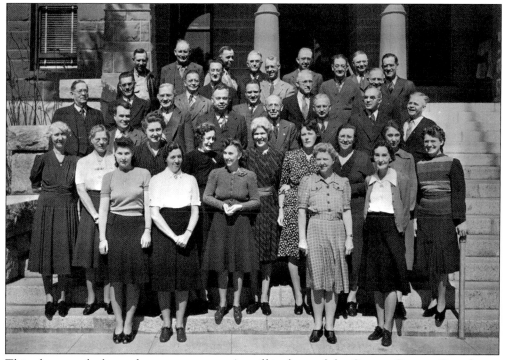

This photograph shows the county assessor's staff in front of the Orange County Courthouse during World War II. (Courtesy of the Orange County Archives.)

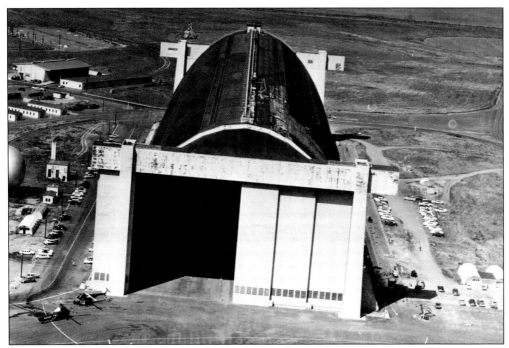

Construction on the blimp hangars at the Santa Ana Naval Lighter-Than-Air Base began in April 1942 and was completed in 1943. The two hangars are among the largest unsupported wood structures in the world. Measuring 1,088 feet long, 178 feet high, and 297 feet wide, they cost $2.5 million each to build. Each hangar could house six blimps, which were used for observation purposes. Later the hangars housed marine helicopters. The base was decommissioned in 1997, and the fate of the two hangars, now national landmarks, is still uncertain. (Both courtesy of Santa Ana Public Library History Room.)

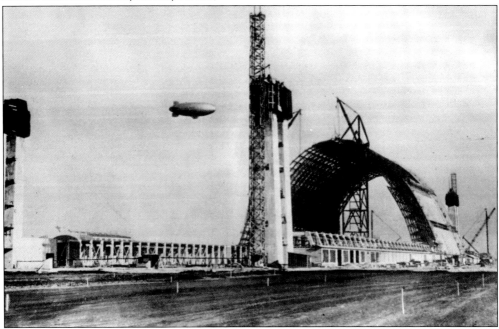

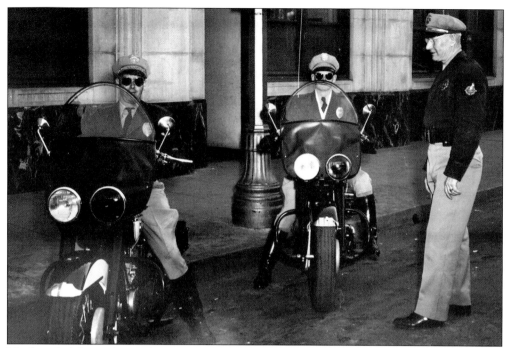

Unidentified Santa Ana Police Department motorcycle officers pose downtown on their Harley-Davidson motorcycles. The photograph was probably taken right outside city hall. (Courtesy of the Santa Ana Police Department Museum.)

Installation of officers is a very serious affair for Silver Cord Lodge 241 at the Santa Ana Masonic Temple. Pictured from left to right are A. H. Allen, C. W. Rowland, and R. G. Tuthill. (Courtesy of the Robert Geivet Collection, Old Courthouse Museum.)

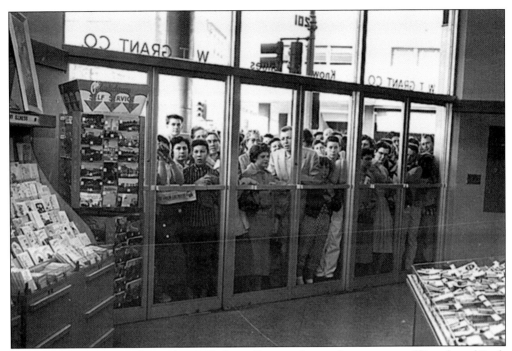

A crowd awaits opening day at the W. T. Grant Store at the northeast corner of Fourth and Bush Streets. Grant's was a five-and-dime-style store similar to Woolworth's. (Courtesy of the Orange County Archives.)

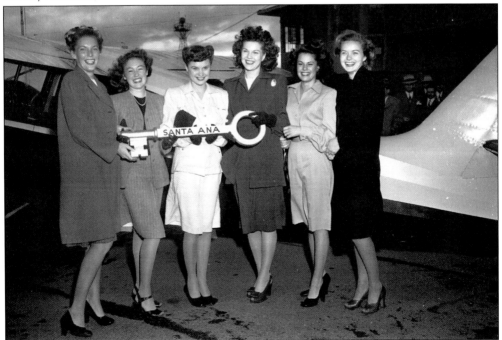

Pictured are the Santa Annual Frolic Queens of 1946. They appear to have been given the keys to the city at the Orange County Airport, just outside the airport tower. (Courtesy of the Robert Geivet Collection, Old Courthouse Museum.)

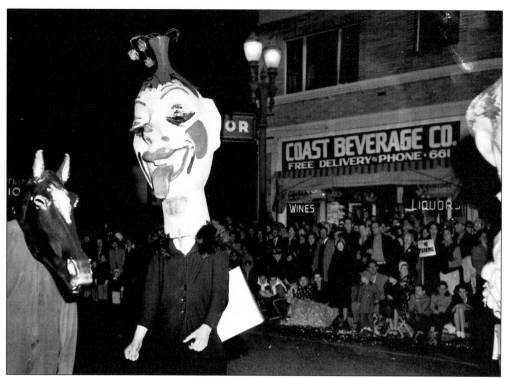

A crowd gathers to watch the Santa Annual Frolic Parade on December 31, 1946. These scenes are from Broadway just south of Third Street. Stein's Studio was located next to the billiard hall pictured in the band photograph. (Both courtesy of the Robert Geivet Collection, Old Courthouse Museum.)

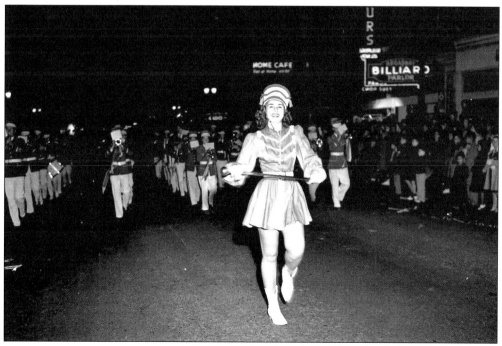

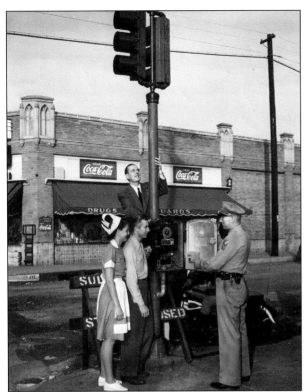

This traffic light at Main Street and Washington Avenue was probably somewhat of a novelty when this photograph was taken on November 29, 1946. The photograph was likely taken on the day of installation or very shortly afterward. (Courtesy of the Santa Ana Police Department Museum.)

Alison Honer and George Wells are the guests of honor at the ground-breaking of an unidentified site in February 1947. The date of the event and the number of young people present suggest that this may be the ground breaking for the Santa Ana College campus at Seventeenth and Bristol Streets. (Courtesy of the Robert Geivet Collection, Old Courthouse Museum.)

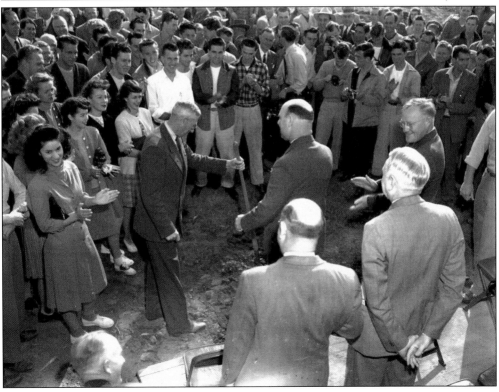

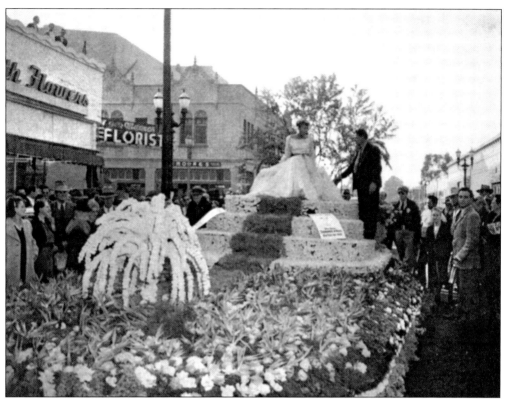

The 1948 Rose Parade Float is shown outside of Macres Florists after it returns from Pasadena. Ruth Raymond is standing on the float. The use of water tubes (actually originally Alka Seltzer bottles) to keep the flowers fresh was an innovation of Albert Macres, and this was the first float to use them. (Courtesy of Michael and Tricia Macres.)

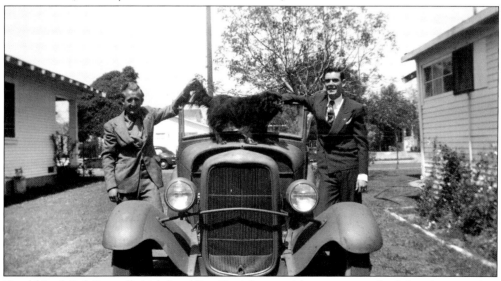

Good friends Bob Runnells (right) and Ron Daniels pose with every teenage boy's favorite possession, their car, at the Runnells home on Third Street. This photograph was taken around the time of their graduation from Santa Ana High School in 1947. (Courtesy of the Bob Runnells family.)

John C. Fremont School was built in 1928 and was located at the corner of Eighth and Artesia Streets, now Civic Center Drive and Raitt Street. Until the early 1960s, this school was located farther west than any Santa Ana elementary school. Shown here in 1948, it was closed following the Sylmar earthquake in February 1971 and demolished the following summer. The new Freemont School was relocated to Tenth and English Streets and boasts a modern design by Ralph Allen. Single-family homes are currently located on the site of the old Fremont School. (Courtesy of Rob Richardson.)

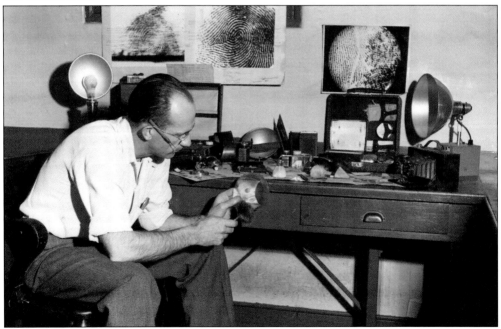

Crime scene investigation has come a long way since this photograph was taken at the Santa Ana Police Department Crime Scene Investigation Office in the early 1940s. It appears that investigation was largely limited to fingerprinting at that time. (Courtesy of the Santa Ana Police Department Museum.)

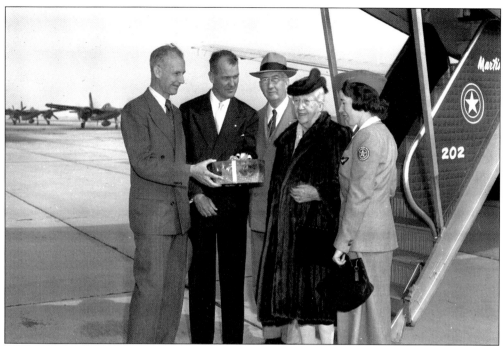

A commemorative plaque erected by the Rotary Club is unveiled on November 4, 1948, at the approximate site of the Martin Garage on Main Street between Second and Third Streets, one block away from where Glenn Martin assembled his first airplane. The historic flight of this plane took place at Main Street and Newport Boulevard on August 1, 1909. The top photograph shows Glenn Martin and his mother, Minta, being greeted as they arrive at Orange County Airport. The bottom photograph shows Martin (left of plaque) flanked by a crowd of Rotarians. (Both courtesy of the Robert Geivet Collection, Old Courthouse Museum.)

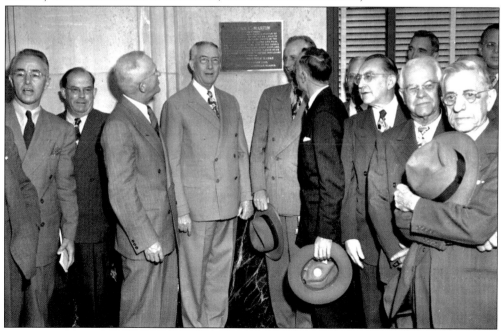

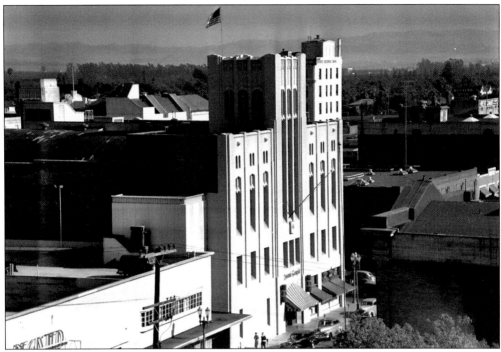

One of the finest examples of zigzag moderne architecture is the Santa Ana Masonic Temple located at 505 North Sycamore Street. Constructed in 1930, it is shown here in 1949. The building featured a lodge hall, auditoriums, a dining hall, ladies lounge, and a tower penthouse. Closed for several years because of seismic concerns, the building was later rehabilitated as the Santa Ana Performing Arts Center and is currently owned by the Scientology Church. (Courtesy of the Robert Geivet Collection, Old Courthouse Museum.)

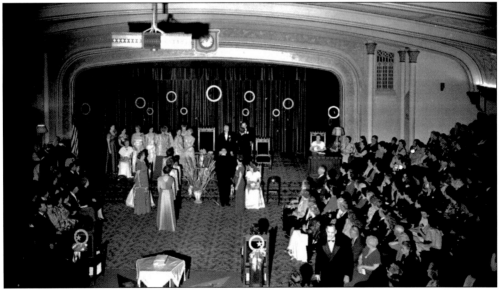

This photograph shows the installation of officers of the Hermosa Chapter, Order of the Eastern Star, on December 12, 1948. The installation took place in the third-floor lodge hall of the Masonic Temple. (Courtesy of the Robert Geivet Collection, Old Courthouse Museum.)

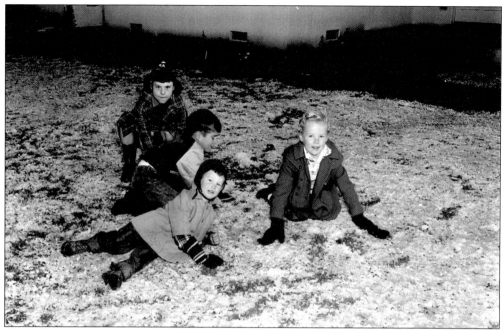

On January 12, 1949, an unusually cold winter resulted in a rare snowfall in Santa Ana. It snowed enough to cover the ground and delight children, many of whom may have never seen snow fall or had the chance to play in it. It was said that if you scraped up the snow from about three front yards you could make a snowman, and a lot of snowball fights probably took place that day as well. (Both courtesy of the Robert Geivet Collection, Old Courthouse Museum.)

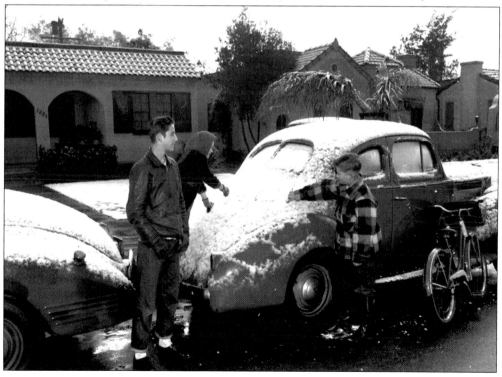

This photograph of the Old Orange County Courthouse was also taken on January 12, 1949, and if you look closely, you can see snow on the ground, but it appears to be starting to melt. Of interest in this photograph is the First Christian Church, built in 1910, in the background. The County Hall of Administration now occupies that site. (Courtesy of the Robert Geivet Collection, Old Courthouse Museum.)

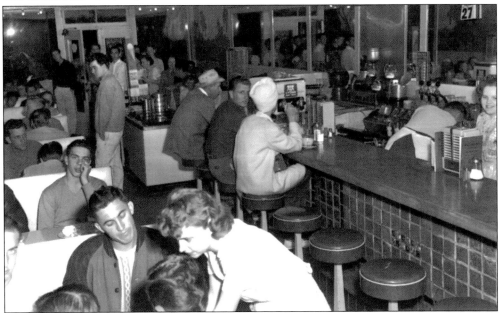

Mary's Malt Shop was located on South Main Street at approximately Chestnut Avenue. Convenient to Santa Ana High School, it was a hangout for high school kids in the 1930s and 1940s. Dinner was also served there. The Malt Shop, as it was known, was a "dry" venue and was popular with teetotalers who did not want to patronize restaurants where liquor was provided. (Courtesy of Rob Richardson.)

Two
1950–1959

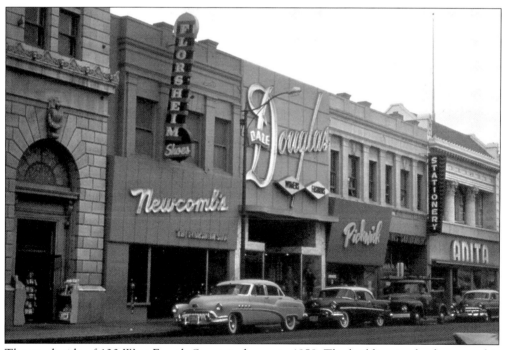

The south side of 100 West Fourth Street is shown in 1958. The building in the foreground is First Western Bank in what was formerly the First National Bank Building. Newcomb's Shoes is next door, and also on this street are Pickwick Books and two women's clothing stores, Dale Douglas and Anita's. (Courtesy of Rob Richardson.)

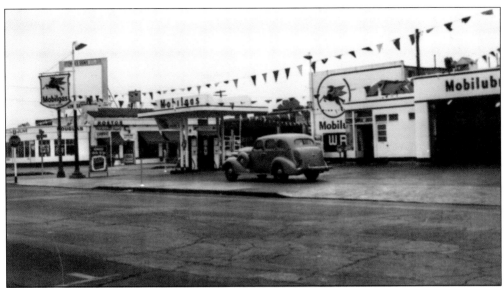

Atkins Service Center, shown here around 1950, was located at Second and Main Streets. (Courtesy of the Bob Runnells family.)

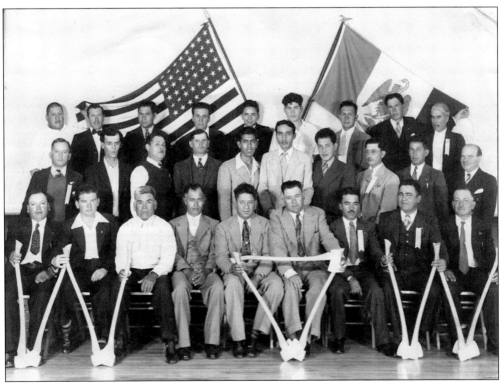

Pictured is a local chapter of the Woodsmen of America, a fraternal organization that sold life insurance. In the 1950s, it was considered prestigious to be a member. The men are from the Santa Ana barrios, mostly from Logan. Alfred Martinez is pictured in the middle row, third from the left. In the first row, fifth from the left, is Ramon Rodriguez. (Courtesy of Delores Martinez Grajeda.)

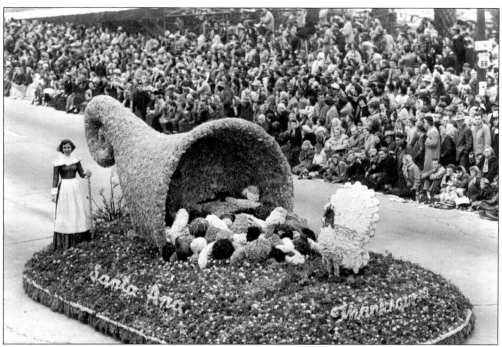
Santa Ana's Thanksgiving-themed 1950 Rose Parade float was a first-prize award winner that year. (Courtesy of Michael and Tricia Macres.)

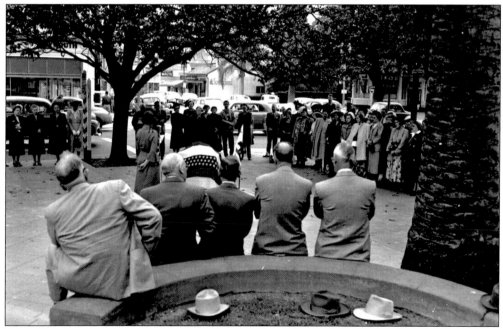
A crowd gathers in front of the Orange County Courthouse for the dedication of a plaque honoring William Spurgeon Sr. on April 25, 1950. The plaque reads: "Santa Ana Parlor, No. 235, Native Daughters of the Golden West, Honors the founder of our city, W. H. Spurgeon, who reserved this site for the Court House in the year 1869. Apr. 24, 1950." William Spurgeon Jr. was in attendance at the dedication. (Courtesy of the Robert Geivet Collection, Old Courthouse Museum.)

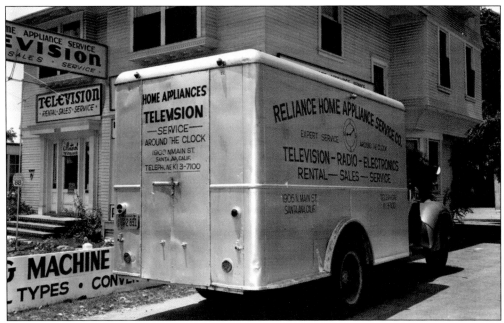

Reliance Home Appliance Services was located at 1906 North Main Street in a converted turn-of-the-century Craftsman-style home. Pictured here on June 26, 1950, the proprietors no doubt entered the modern age of electronics early on and by 1950 were already able to rent, sell, and service radios, televisions, and other electronics. (Courtesy of the Robert Geivet Collection, Old Courthouse Museum.)

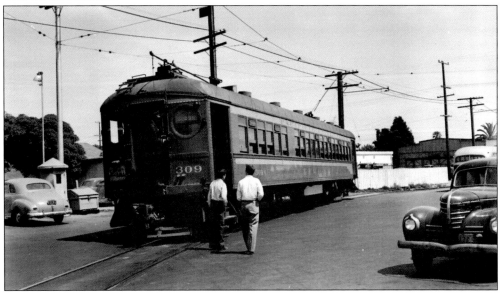

Known popularly as the Red Car, the Pacific Electric Railway was founded by Henry Huntington in 1901. Bought by Southern Pacific in 1911, the Pacific Electric was the largest operator of interurban electric railway in the world, with over 1,000 miles of track. With the increasing popularity of the automobile affecting its ridership, the last passenger run on the Santa Ana line took place on July 2, 1950. In 1953, all remaining Pacific Electric passenger service was sold to Metropolitan Coach Lines. (Courtesy of the Robert Geivet Collection, Old Courthouse Museum.)

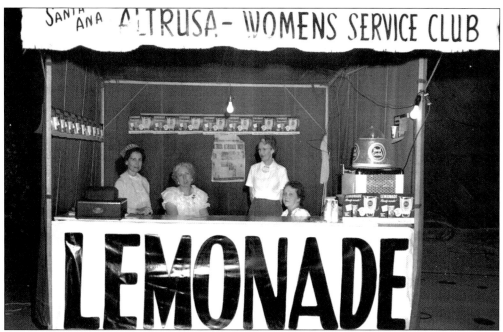
The Santa Ana chapter of the National Association of Altrusa Clubs sells lemonade at its booth at the Orange County Fair on August 17, 1950. A women's civic organization, Altrusa required its members to be working professionals and emphasized vocational education for women. (Courtesy of the Robert Geivet Collection, Old Courthouse Museum.)

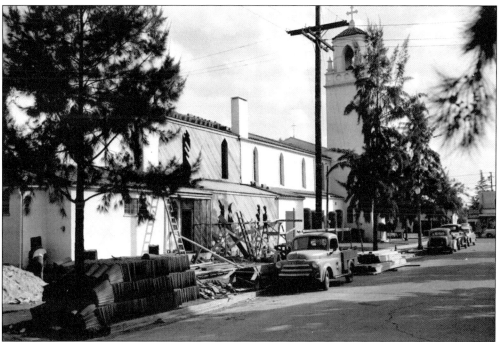
St. Ann's Catholic Church, located at South Main and Borchard Streets, was built in 1923. Here construction of an addition to the original sanctuary is shown in October 1950. (Courtesy of the Robert Geivet Collection, Old Courthouse Museum.)

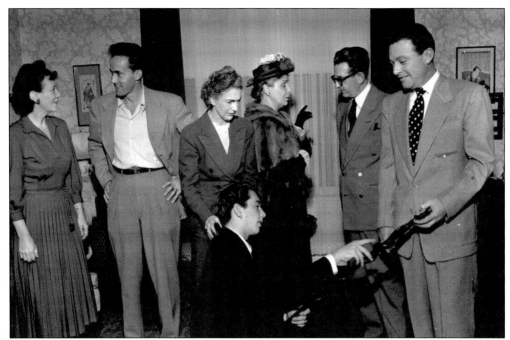

The Santa Ana Community Players were founded by Ernest Crozier Phillips in November 1919. Phillips was the head of the Department of Expression at Santa Ana High School at the time. Actors in the group were members of the community who enjoyed theater performance. In early years, they performed at the "new" high school auditorium. By the time this January 1951 photograph was taken, they were performing at the theater in the Ebell Clubhouse. (Courtesy of the Robert Geivet Collection, Old Courthouse Museum.)

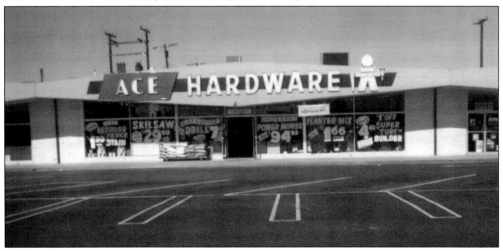

Woodward's Ace Hardware was originally located at 1002 East Seventeenth Street in the Certified Center. The store was originally a Knox Hardware, a retail location for Knox Brothers Hardware on South Grand Avenue. The business was sold to Dick and Joan Woodward and was the first Ace Hardware in California and west of Tucson. Woodward's moved to its present location at 2343 North Tustin Avenue in 1976 and expanded with a store in Orange in 2003. Woodward's Ace Hardware is still a family-owned business and prides itself on being customer friendly. (Courtesy of Bill Woodward.)

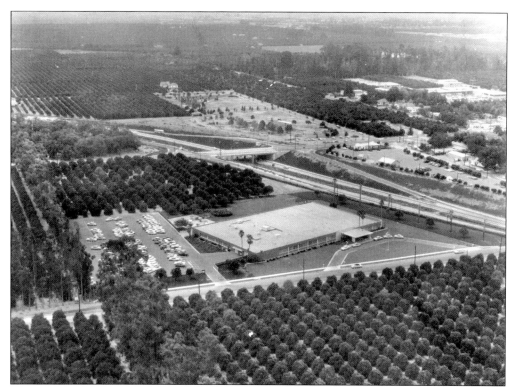

The Allstate Insurance regional office was located at 1750 East Fourth Street. A second floor was later added to the building. In the mid-1980s, it was sold, demolished, and replaced with the eight-story State Fund Insurance Building. At the center of the photograph is the First Street bridge over the Santa Ana Freeway; Prentice Park is just beyond. (Courtesy of Rob Richardson.)

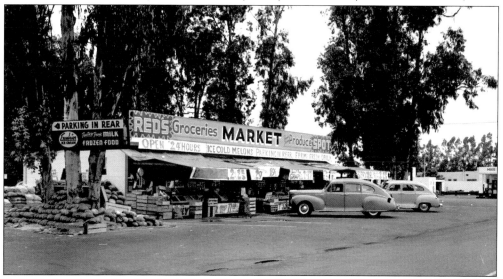

Red's Market, pictured on July 19, 1951, and located at First Street and Harbor Boulevard, appeared to be a combination grocery store and produce stand. Note the sign on the left, advertising Excelsior ice cream (local to Santa Ana) and "pasture fresh" milk, which in those days no doubt really was from a nearby pasture. (Courtesy of the Robert Geivet Collection, Old Courthouse Museum.)

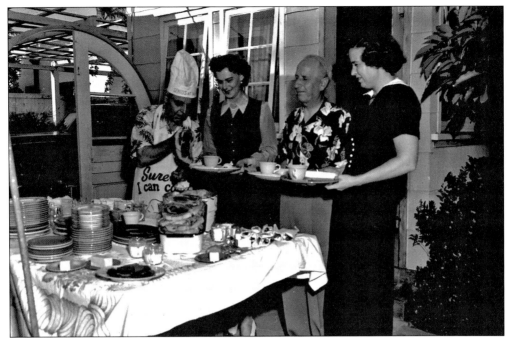

Harry Macres of Macres Florists serves steak at a "steak bake" at his home at 1124 South Ross Street on July 20, 1951. Harry was the father of Albert Macres (who pioneered the use of water bottles to keep flowers fresh on Rose Parade floats) and is the grandfather of current Macres Florists owner Michael Macres. (Courtesy of the Robert Geivet Collection, Old Courthouse Museum.)

The All-Woman Transcontinental Air Races formally began in 1948, descending from what had originally been known as the Powder Puff Derby in 1928. August 15 marked the beginning of the 1951 race, which started at Orange County Airport in Santa Ana and ended in Detroit. Claire McMillan and Frances Bera, both of Orange County, piloting a Cessna 140, won the race that year. (Courtesy of the Robert Geivet Collection, Old Courthouse Museum.)

This mural, which was located in the Yorba Tea Room at Buffums' Department Store at Tenth and Main Streets, is a fanciful interpretation of early local history featuring stylized images of an American Indian, Portolá, Mission San Juan Capistrano, Spanish ships, and various elements of nature. It was completed in April 1950 by artist Joseph S. Donat (1919–1998). After Buffums' closed, county services began to occupy the building, including Child Support Services. The mural is still intact in one of the courtrooms. (Courtesy of the Robert Geivet Collection, Old Courthouse Museum.)

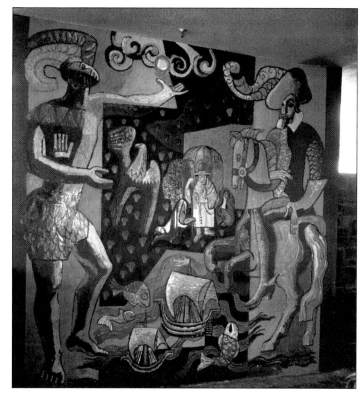

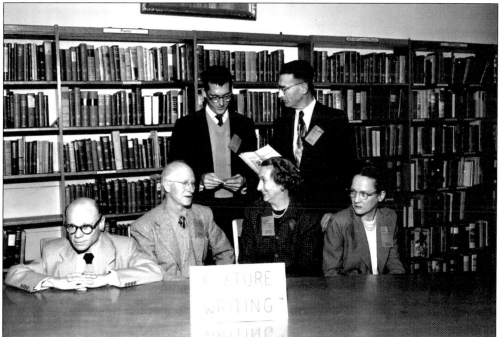

Participants in the Santa Ana College Writers Conference on December 5, 1951, are pictured. On the far left is Gerald Lagard, author of *Leaps the Live Thunder*. (Courtesy of the Robert Geivet Collection, Old Courthouse Museum.)

Standing from left to right are James Utt, Nancy Card, and E. A. Fishburn at the Associated Chamber of Commerce Civic Night on October 30, 1951. In 1952, Utt would be elected to the 83rd U.S. Congress. (Courtesy of the Robert Geivet Collection, Old Courthouse Museum.)

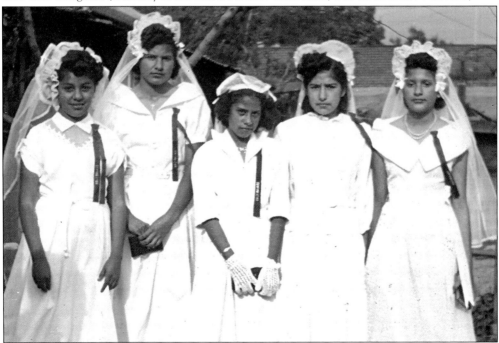

The Luna, Parga, Rodriguez, and Ochoa girls (order unknown) are dressed up for their confirmation rites through the Catholic Church. The girls are posing at a house in Santa Ana's Logan neighborhood. (Courtesy of Sonny Granados.)

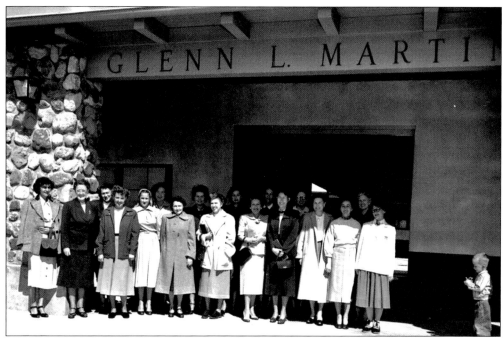

The ladies of the Glenn L. Martin School PTA pose at the front entry to the school in March 1952. Located at 939 West Wilshire Avenue, the school opened in 1951; thus, this would be the first PTA organized there. The school was named for aviator Glenn Martin, who built his first plane in Santa Ana. (Courtesy of the Robert Geivet Collection, Old Courthouse Museum.)

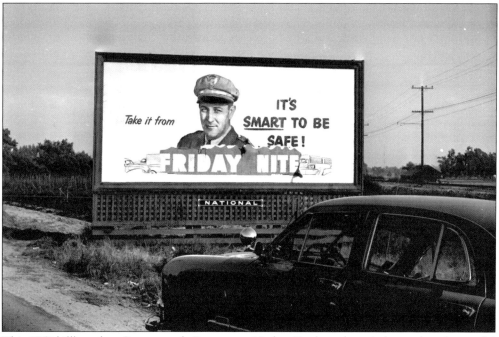

This 1952 billboard on Seventeenth Street near Harbor Boulevard reminds people to be careful during their Friday night fun. Note that the area was largely a farming community at that time. (Courtesy of the Robert Geivet Collection, Old Courthouse Museum.)

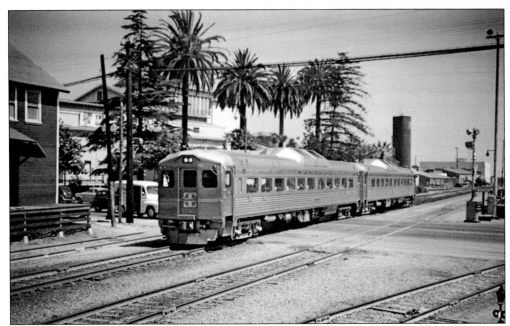

In the early 1950s, the Santa Fe Railway used self-propelled rail diesel cars (RDCs) for passenger service between San Diego and Los Angeles, known as the Atchison, Topeka, Santa Fe San Diegan to Los Angeles. Pictured on July 3, 1952, these two cars are crossing Fourth Street just after leaving the Santa Fe Depot at 1038 East Fourth Street. Service on this line was cut short after the two cars were involved in an accident in Vernon in late 1952, resulting in 30 deaths. Note the Treesweet Juice packing plant behind the palm trees. (Photograph by Tom Gildersleeve, courtesy of Rob Richardson.)

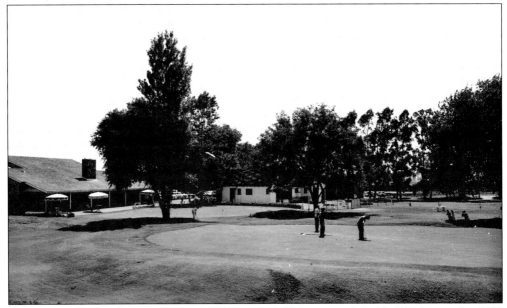

Golfers try out their skill at the game at Willowick Golf Course on July 15, 1952. Located at 3017 West Fifth Street, Willowick was designed by William Bell and opened in 1929. (Courtesy of the Robert Geivet Collection, Old Courthouse Museum.)

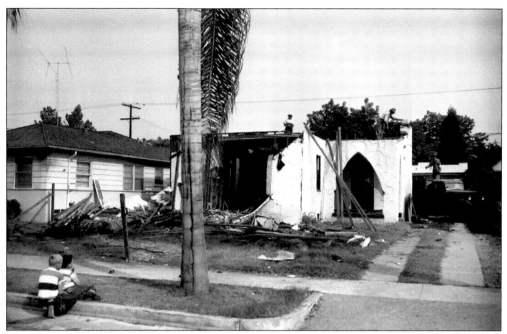

In July 1952, a small plane crashed into the Stedman home at 1305 South Parton Street, killing the pilot and destroying the house. Neighborhood boys watch while workers begin the job of demolishing the damaged Mediterranean Revival–style home. Constructed in its place was a 1950s-style home. (Courtesy of the Robert Geivet Collection, Old Courthouse Museum.)

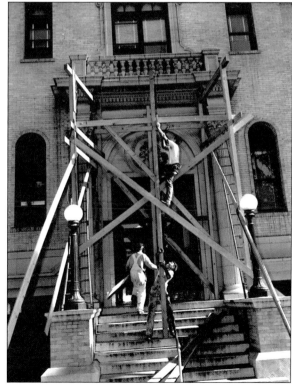

The magnitude 7.5 earthquake in Kern County on July 21, 1952, was the largest in Southern California since 1872 and was felt as far away as San Diego and San Francisco. Several aftershocks also resulted in damage. Workers repair damage sustained at the County Hall of Records as a result of this earthquake. (Courtesy of the Robert Geivet Collection, Old Courthouse Museum.)

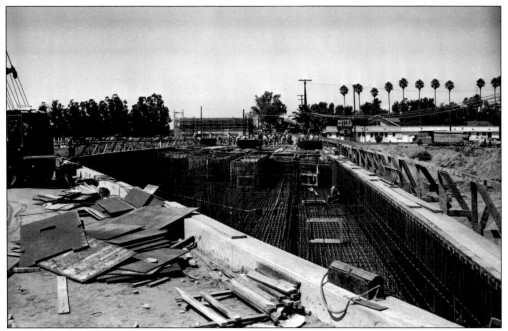

Massive amounts of steel and concrete are used in the construction of the Main Street Bridge at the Santa Ana Freeway in August 1952. The Motel Deluxe at 2409 North Main Street is shown in the background. The motel was demolished in the early 1990s to make way for widening of the Santa Ana Freeway. (Courtesy of the Robert Geivet Collection, Old Courthouse Museum.)

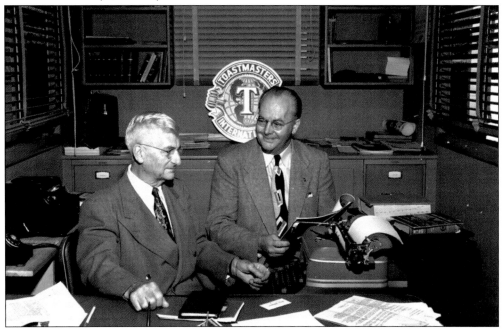

Pictured are Ralph Smedley (left) and Wayland Dunham at the Toastmasters Office in 1952. Ralph Smedley was the founder of Toastmasters International. Wayland Dunham was author of the 1948 book *It's a Date*, about the date industry in Palm Springs. (Courtesy of the Robert Geivet Collection, Old Courthouse Museum.)

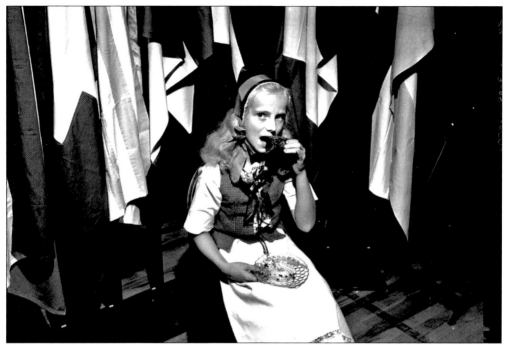

Mary Ann Jensen, representing Denmark, takes a refreshment break at the All Nations Festival at the Santa Ana YMCA on October 1, 1952. (Courtesy of the Robert Geivet Collection, Old Courthouse Museum.)

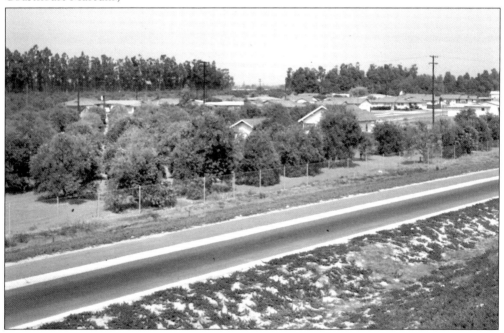

The Santa Ana Freeway appears to be little more than a two-lane highway as shown here near Bristol Street. This location is very close to where the "Orange Crush" (5, 57, and 22 Freeways interchange) currently exists, and while it does not appear that any of these homes have been lost to progress, the view is far different now than what it was then. (Courtesy of the Orange County Archives.)

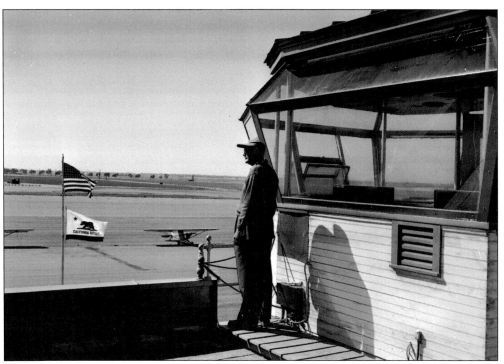

Manager William Nichols looks out at the Orange County Airport from his vantage point at the airport tower. (Courtesy of the Robert Geivet Collection, Old Courthouse Museum.)

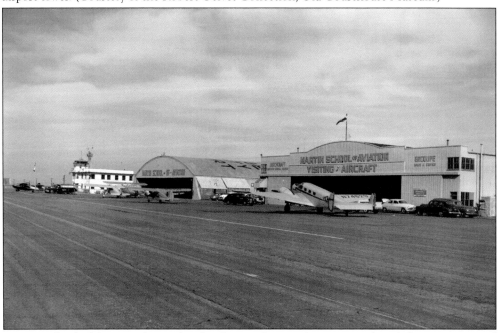

Martin School of Aviation, located at the Orange County Airport, was founded as a commercial school of aviation by Eddie Martin. This photograph shows the Martin School of Aviation Hangars in the foreground and the airport's administrative building in the background. (Courtesy of the Orange County Archives.)

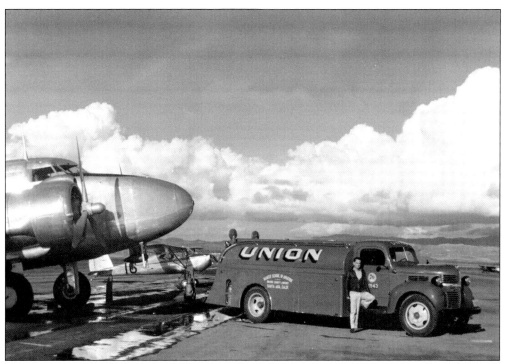

A Martin Aviation fuel truck refuels one of their planes during the 1950s. The side of the truck reads "Martin School of Aviation, Orange County Airport, Santa Ana, CA." (Courtesy of the Orange County Archives.)

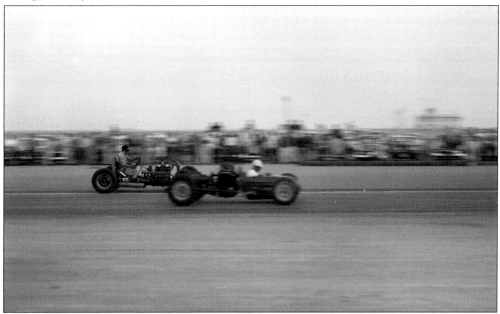

Drag racing was a popular sport at the Orange County Airport in the 1950s. Participants would come from all over Southern California for the races, which were held every Sunday from 8:00 a.m. to dusk. The races were popular and sometimes had more than 2,500 spectators in attendance. This was the first sanctioned drag strip in the country. (Courtesy of the Bob Runnells family.)

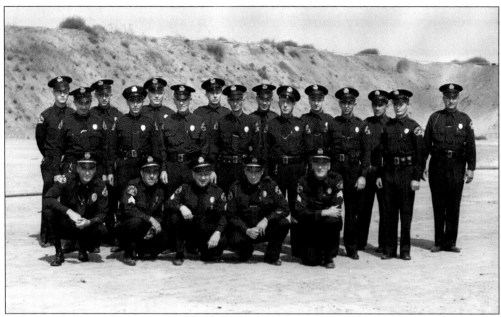

Santa Ana police officers and reserve officers pose for a formal photograph on August 23, 1953. From left to right are (first row) Capt. Forrest L. Duke, Sgt. John S. Geiger, Sgt. Eugene Schaefer, Lt. Robert Smith, and Sgt. Milton Cook; (second row) officers Ernest Pittsenbarger, Harold Mize, Roy W. Beal, P. J. Vest, R. E. Brattain, Otis D. Awalt, and William Young; (third row) officers Curtis Sissel, William Jiles, John Slusher, H. M. Collier, Allie Wilkenson, George Schaefer, E. Sigala, and D. Mitchell. (Courtesy of the Santa Ana Police Department Museum.)

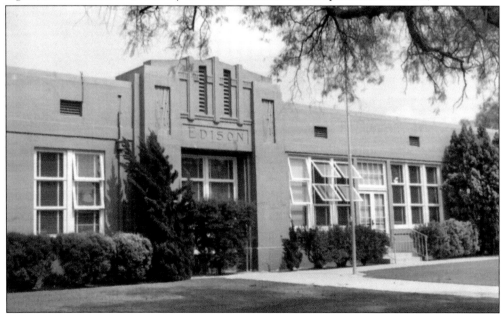

Edison Elementary School is located at 2067 South Orange Avenue. Pictured here in the 1950s, it was built in 1937 and was Frederick Eley's last school design in both Santa Ana and Southern California. Edison and Franklin (originally Spurgeon) Elementary Schools are the only Eley-designed schools that remain in Santa Ana. (Courtesy of Rob Richardson.)

Roosevelt Elementary School, shown here in the 1950s, was built in 1924 and located at 318 East First Street. Designed by Frederick Eley, it had replaced the First Street School at the same location. It was closed in 1971 and used as a school district warehouse until it was torn down in 1980. (Courtesy of Rob Richardson.)

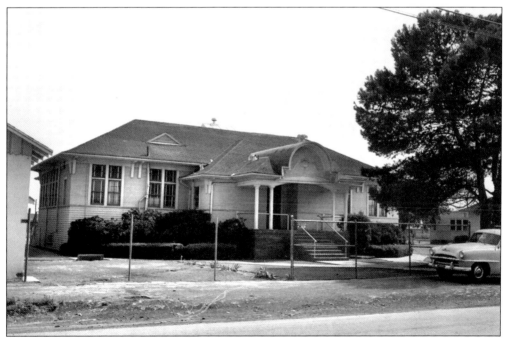

Shown here in 1954, Delhi School opened in 1914 and was located at 402 East Delhi Road (later renamed Warner Avenue). It had four rooms and cost $6,400 to build. (Courtesy of Rob Richardson.)

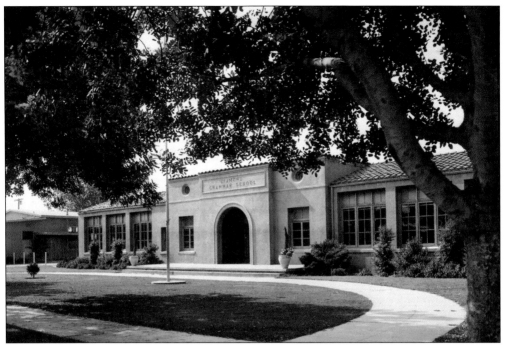

Diamond Grammar School is pictured in 1954. This facility no longer exists; currently Diamond Elementary School is located at 1450 South Center Street. (Courtesy of Rob Richardson.)

Washington Elementary School, shown here in 1954, was built in 1949 in response to growth in residential housing at the south end of Santa Ana. Located at the intersection of Warner Avenue and Flower Street, it is still in use today, although now supplemented by portable buildings to accommodate growing enrollment. (Courtesy of Rob Richardson.)

The two-story school pictured is Wilson Elementary School, as seen in 1954. The school was built in 1928, closed in February 1971 after the Sylmar earthquake that month, and subsequently demolished the following summer. (Courtesy of Rob Richardson.)

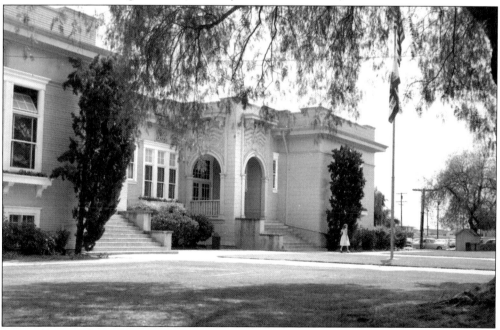

Pictured here in the 1950s, this handsome wood-frame school is Jefferson Elementary School, which was built in 1910 at the southeast corner of Seventeenth and Ross Streets. It was demolished in 1965, and an Alpha Beta Market and Hy-Lo Drug Store were built at the same location. (Courtesy of Rob Richardson.)

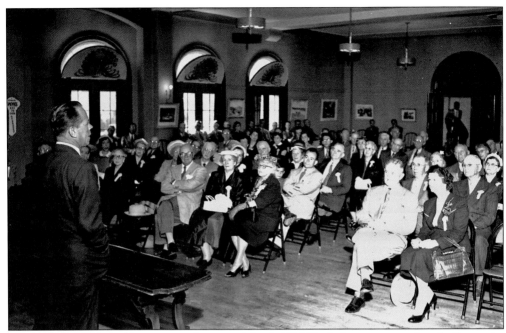

Sen. Thomas Kuchel addresses an audience on May 1, 1954. Kuchel was appointed to the Senate by Gov. Earl Warren when the seat was vacated by Richard Nixon after his election as vice president. The moderate Republican served the remainder of Nixon's term and two subsequent terms before leaving office in 1969. (Courtesy of the Robert Geivet Collection, Old Courthouse Museum.)

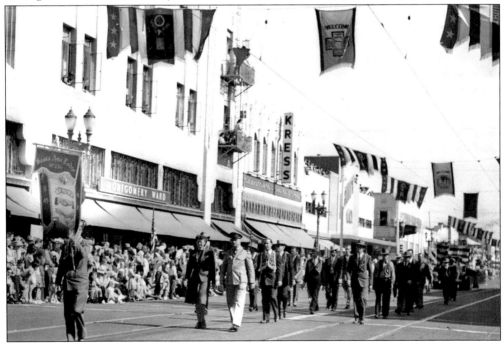

The Santa Ana Lodge of the Independent Order of Odd Fellows marches in a parade down Fourth Street. They are seen here approaching Main Street, past the Montgomery Ward and Kress stores. (Courtesy of Rob Richardson.)

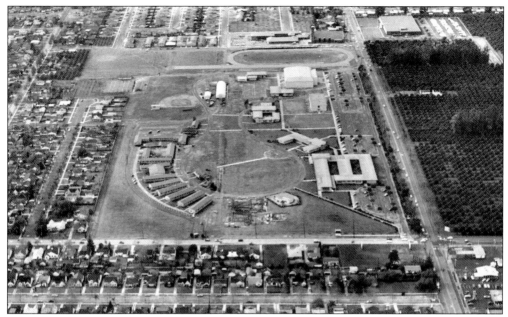

Santa Ana College is shown at its current location at Seventeenth and Bristol Streets in the late 1950s. At this point, several buildings and the athletic field had been developed. Ground breaking on Honer Plaza (to the right side of the photograph) has not yet occurred. Right behind the athletic field, the First Christian Church can be seen, which dates the photograph to 1956 or later. (Courtesy of Rob Richardson.)

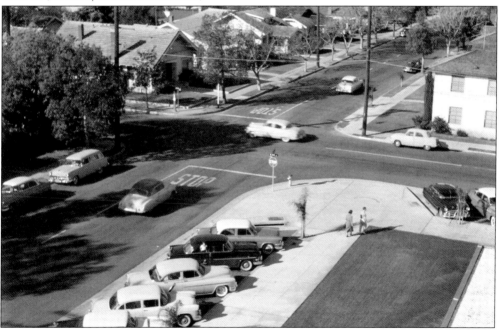

Pictured here in 1956, the intersection of Eighth and Ross Streets has undergone significant changes since then. Houses have been demolished to make way for county facilities. The southwest corner of the intersection became home to the new Santa Ana Public Library a few years later. Eighth Street would become Civic Center Drive in the 1970s. (Courtesy of the Orange County Archives.)

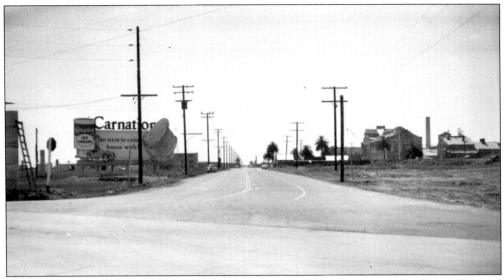

Holly Sugar operated this facility, which processed sugar beets for beet sugar, from 1918 until 1982. Prior to 1918, it was known as the Santa Ana Cooperative Sugar Company and was owned by James Irvine, among others. It was located on East Dyer Road near Grand Avenue, seen here in 1956. After it was demolished in 1983, the Embassy Suites Hotel and the Birtcher Orange County Tech Center were built on the site in 1985. Very few people who remember the sugar factory will forget the not-so-sweet odor of sugar beets processing, but most still have fond memories anyway. Note also the Carnation Ice Cream billboard on the left. (Courtesy of the Orange County Archives.)

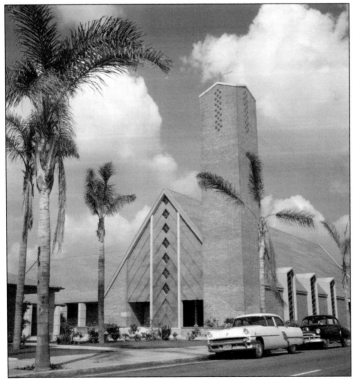

The First Christian Church relocated from its downtown location at Sixth and Broadway Streets to the edge of town at 1720 West Seventeenth Street, across from Santa Ana College, in 1956. The sanctuary, with its carillon bell tower and stained-glass windows, is shown here. Dwindling membership led the congregation to sell the property to Santa Ana College in 2002, and the sanctuary was demolished a few years later. (Courtesy of the Orange County Archives.)

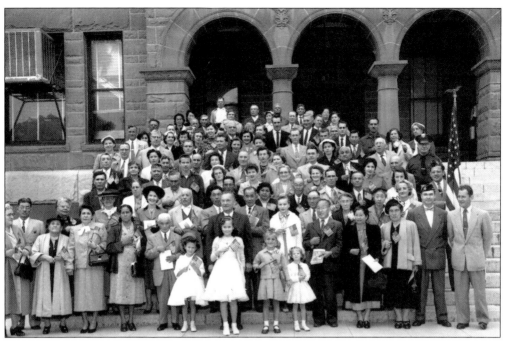

Newly naturalized U.S. citizens pose on the steps of the Orange County Courthouse, proudly waving the flag of their new country, in 1956. (Courtesy of Rob Richardson.)

In 1957, the Santa Ana Freeway, or 5 Freeway, had only two lanes in each direction. This aerial looks northwest over the freeway. In the foreground are Lincoln Avenue and the Santa Fe Railway tracks. The large orange grove on the right side is now the site of Guaranty Chevrolet. (Courtesy of Rob Richardson.)

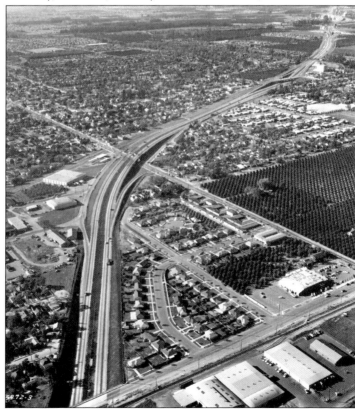

Ross Street between Sixth and Eighth Streets (later Santa Ana Boulevard and Civic Center Drive) is shown with two newly constructed county buildings. The Santa Ana Public Library is the building currently under construction. St. Ann's Inn, the Old Courthouse, First Christian Church, and the Masonic Temple can all be seen in the background. (Courtesy of Rob Richardson.)

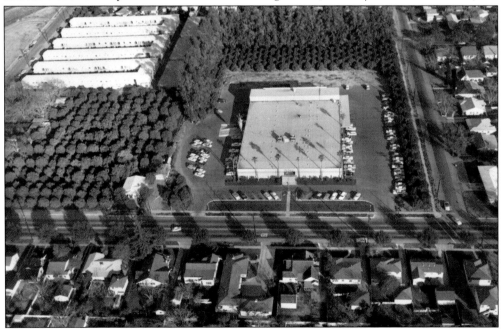

By 1958, the *Orange County Register*, then known simply as *The Register*, had moved its offices from downtown to its current location on Grand Avenue. A house, seen in the orange groves to the left of the building, still stands today, though the orange groves around it have long since disappeared. (Courtesy of Rob Richardson.)

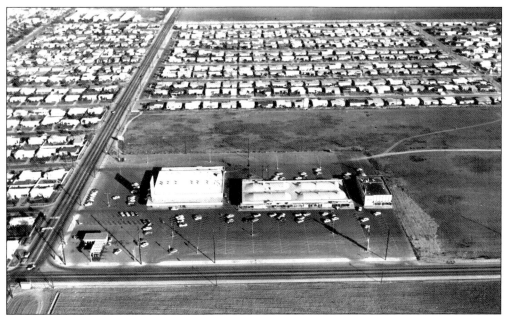

Bristol Shopping Center, located at Bristol Street and Warner Avenue, was anchored by a Market Basket Store, shown here on the left. The building in the middle included Gallenkamps, a Cornet store, and Knox Hardware. The building on the right side is a branch office of Security Pacific Bank. The undeveloped area at the top of the photograph is at Flower Street; Washington School can be seen on the top left. (Courtesy of Rob Richardson.)

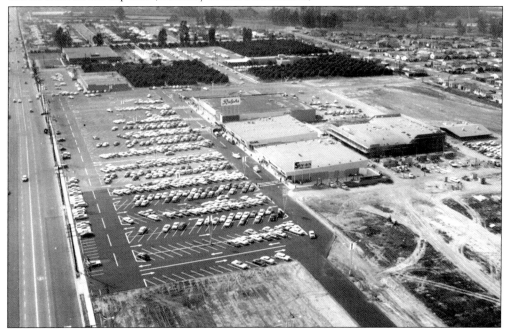

In this view of Honer Plaza, the shopping center was not yet completed. Anchor stores Ralph's Grocers, Sav-On, and Newberry's (located on the north side) were open, as well as some smaller stores, including Thom McAn Shoes, in between Ralph's and Sav-On. Montgomery Ward did not move to Honer Plaza until 1960. (Courtesy of Rob Richardson.)

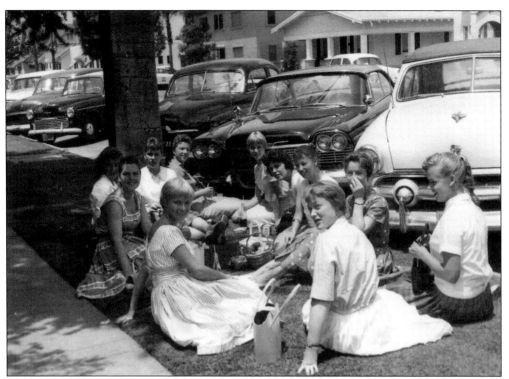

A group of Santa Ana High School students eat lunch on the grassy parking near the school. Note the c. 1900 homes across the street. Many of the homes that were nearest to the school have been demolished over the years to make room for school expansion. (Courtesy of Rob Richardson.)

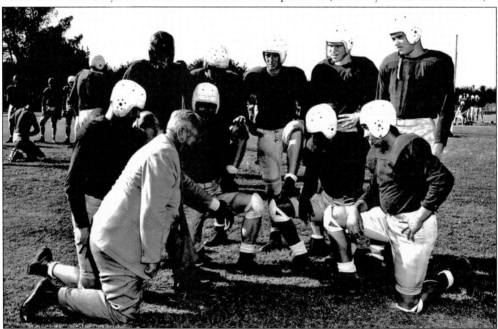

Santa Ana High School football players are shown in their new football uniforms with coach Bill Cook. (Courtesy of the Robert Geivet Collection, Old Courthouse Museum.)

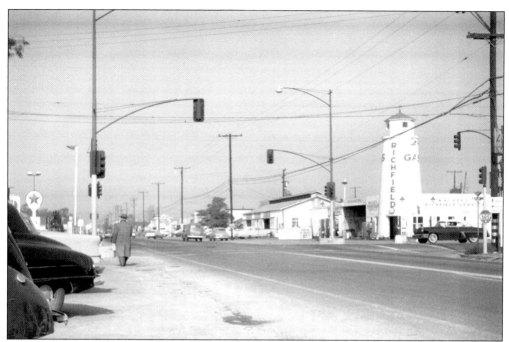

This Richfield Gas Station was located at the intersection of First Street and Harbor Boulevard. The photograph was taken in January 1957. (Courtesy of the Orange County Archives.)

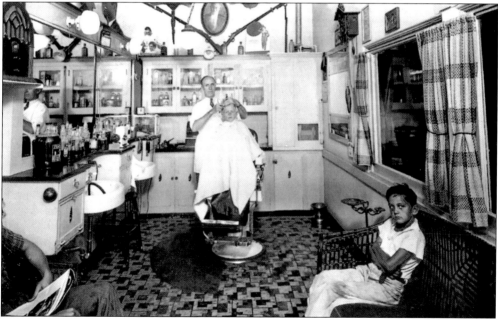

Mel Lamb learned to cut hair and shoe mules during World War I. There was likely more demand for cutting hair than shoeing mules after the war was over, and Mel continued in this vocation for many years. He is seen here in his shop located at the intersection of McFadden and Main Streets. Pop's Bicycle Shop and Gracie's Restaurant were also located in the same shopping center. Just recently, the mall underwent extensive rehabilitation and bears little resemblance to the original construction. (Courtesy of Glen and Julie Stroud.)

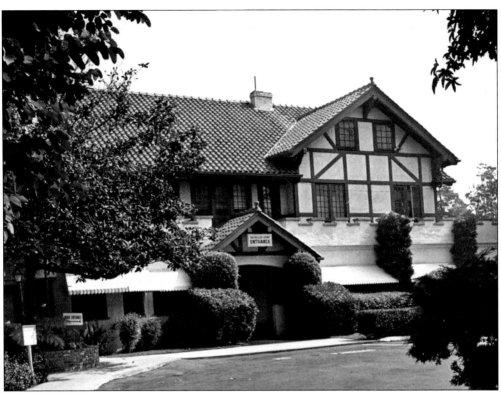

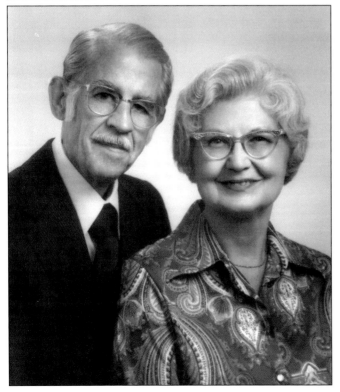

Now known as the Twist-Basler House, this home, located at 1015 North Broadway, was built in 1914 by Nathan A. Twist, president of the Lutz Company. It was subsequently owned by Dr. Jess Burlew, then purchased by Dr. Herman and Virginia Basler in 1944 and converted into one of the first proprietary convalescent homes in Orange County. The Baslers, pictured at left, operated the home until the 1980s. At one time slated for demolition to make room for One Broadway Plaza, a 37-story office building, the house currently sits in four pieces, awaiting relocation to Cabrillo Park, where it will be restored as a fitness center. (Both courtesy of Nancy Basler Bjorklund.)

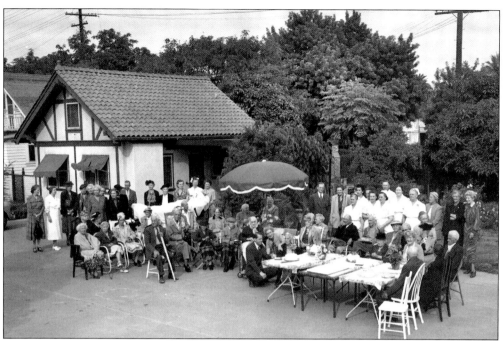

Residents and nurses gather together for a social event in the backyard of the Basler Convalescent Home on North Broadway. Dr. Basler is in the center of the photograph with an elderly lady who appears to be the "birthday girl," as indicated by the cake with candles. (Courtesy of Nancy Basler Bjorklund.)

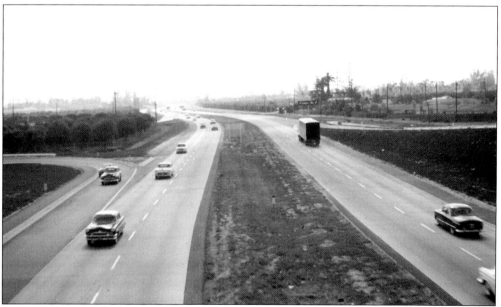

The Santa Ana Freeway once had an exit onto Flower Street. At that time, Flower Street extended all the way north to Chapman Avenue. This photograph dates to some time before 1957, the year that Farmers Insurance would be built in the lower right portion of the photograph. Fashion Square would be built on the opposite site of the freeway in 1958. At one time, this area was known as West Orange. (Courtesy of the Orange County Archives.)

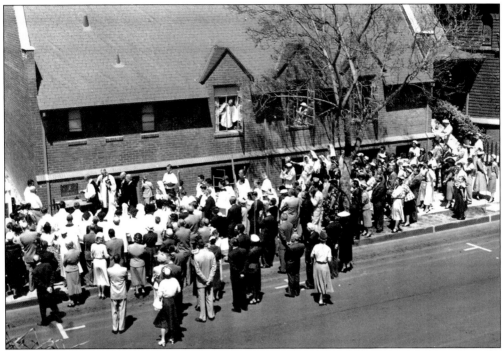

Church members turn out to celebrate the dedication of the Episcopal Church of the Messiah's recent expansion. The church is located at the southwest corner of Bush Street and Civic Center Drive. The original building was constructed in 1889, and the facility has been in continuous use by the same congregation the entire time. (Courtesy of Rob Richardson.)

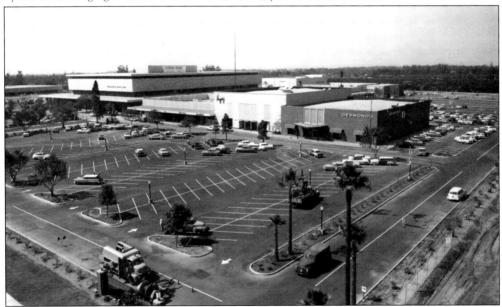

Fashion Square, built in 1958, was Santa Ana's only shopping mall at the time and was considered upscale shopping. It was anchored with Bullocks and Desmonds. As indoor shopping malls became preferred, Fashion Square was considered dated and fell on hard times. Main Place Mall was developed in the same location in the late 1980s. (Courtesy of Rob Richardson.)

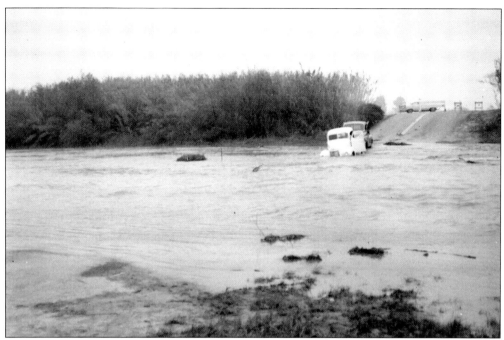

Heavy rains in early March 1958 made for a treacherous crossing on Edinger Avenue at the Santa Ana River. Hopefully these two vehicles did not float away before they had a chance to safely cross. (Courtesy of County of Orange, Resources and Development Management Department/Flood Control District.)

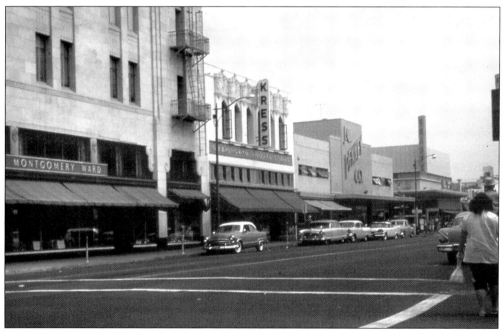

In 1958, Fourth Street in downtown Santa Ana was a preferred shopping destination. Looking east toward Bush Street from Main, Montgomery Ward, Kress, and J. C. Penney were all on the same block. On the other side of Bush Street was W. T. Grant's. (Courtesy of Rob Richardson.)

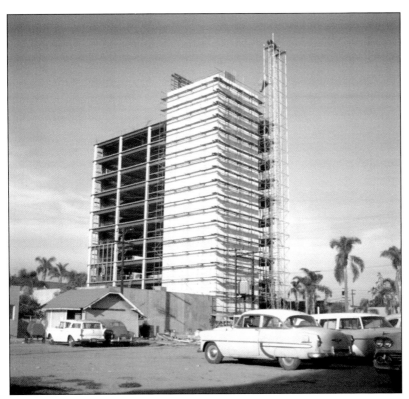

The Citizens Bank Building, located on the southwest corner of Broadway and Tenth Streets in 1959, was 10 stories tall and was the tallest building in Santa Ana at the time. Building amenities did not include air-conditioning. The Galaxy Restaurant was located on the 10th floor. (Top courtesy of the Orange County Archives, bottom courtesy of Rob Richardson.)

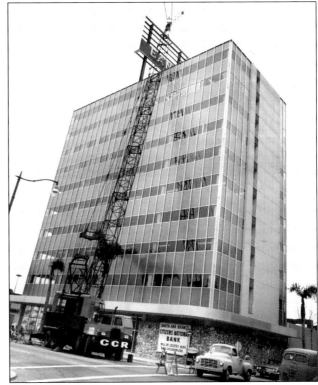

A very tall reach forklift is used to remove pallets of materials from the Carnegie Library in preparation for the move to the new library at Eighth and Ross Streets. (Courtesy of Rob Richardson.)

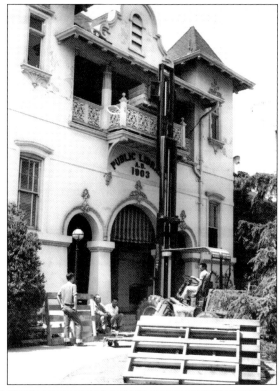

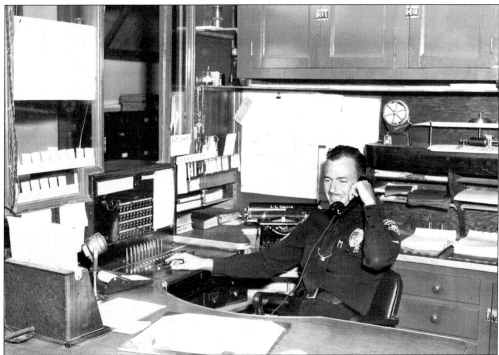

Sgt. Bill Hatch is seen in the Dispatch Office of the Santa Ana Police Department in the late 1950s. (Courtesy of the Santa Ana Police Department Museum.)

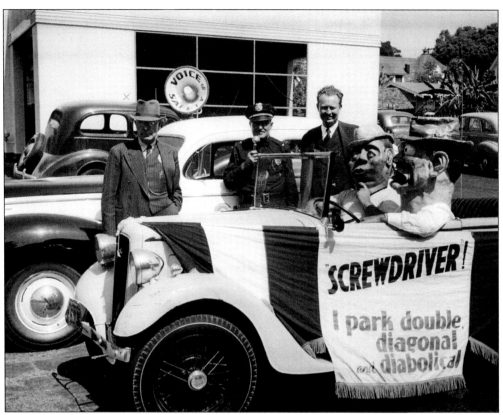

Even in the 1950s, drunk driving was a serious issue, and the Santa Ana Police Department launched an awareness campaign to combat the problem. The gentleman with the microphone is believed to be Chief Hershey. (Courtesy of the Santa Ana Police Department Museum.)

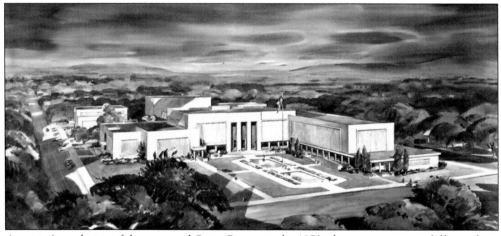

An artist's rendering of the proposed Civic Center in the 1950s shows a scene very different from what eventually became the final design. (Courtesy of Rob Richardson.)

Three
1960–1969

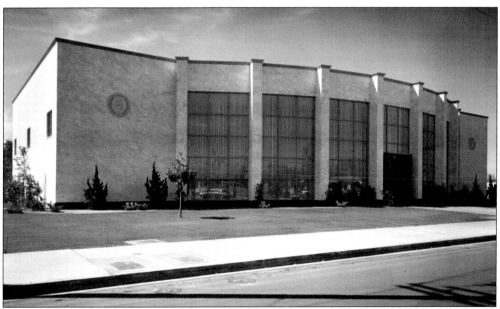

The newly constructed Santa Ana Public Library located at Eighth Street (later Civic Center Drive) and Ross Street was opened in 1960. It replaced the original Carnegie Library built in 1903 and located on Sycamore Street. (Courtesy of the Santa Ana Public Library History Room.)

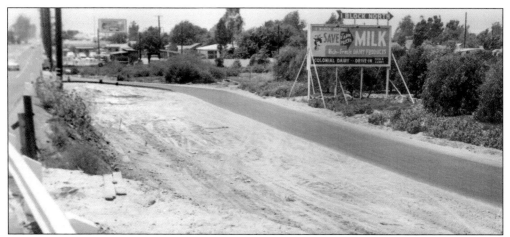

This c. 1960 photograph of Bolsa Avenue, as First Street was known in the west side of town, shows a much more rural street than it is today. Located near Harbor Boulevard, many dairies occupied the area at that time, and until development pushed them out of Orange County, cows grazed in the fields there. A trip to the dairy was a treat for many children, who could do some "cow watching" while Mom bought milk. (Courtesy of the Orange County Archives.)

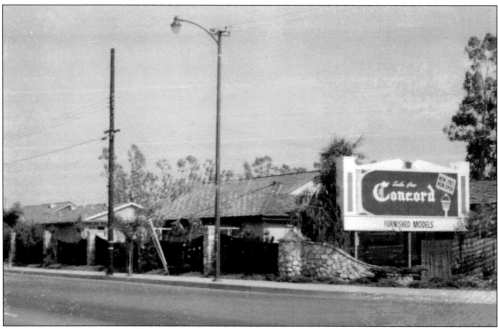

An early neighborhood of tract homes could be found at Santa Ana Concord, which bordered Memory Lane between Flower and Bristol Streets. The neighborhood is still a nice-looking tract. This photograph was taken about the time of the tract's opening in August 1960. (Courtesy of the Orange County Archives.)

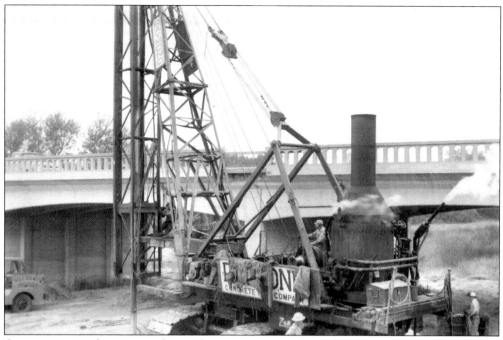
Construction workers operate heavy-duty equipment in the bed of the Santa Ana River during the widening of the First Street Bridge in 1960. (Courtesy of the Orange County Archives.)

Children and parents alike turn out for a day of fun at the PTA Carnival at Monte Vista Elementary School in 1960. In the days before video games and the Internet, activities like these were popular and brought out the crowd. They were also fund-raisers for the sponsoring PTA groups. (Courtesy of the Bob Runnells family.)

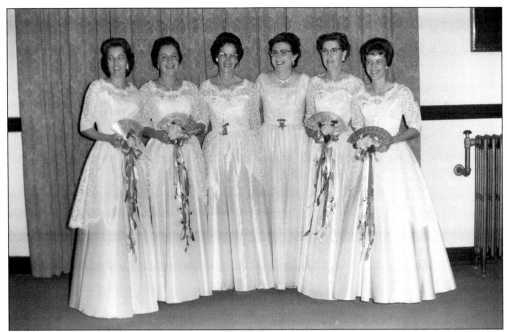

Officers of the Hermosa Chapter, Order of the Eastern Star, pose at the Santa Ana Masonic Temple in their formal gowns. This appears to be either an installation of officers or a visit from state officers of the organization. Madeline Runnells is second from the right. The other ladies are unidentified. (Courtesy of the Bob Runnells family.)

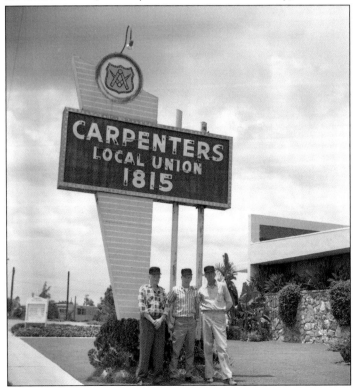

Members pose outside the union hall for the Carpenters Union, Local 1815, located at 2829 West First Street. (Courtesy of the Bob Runnells family.)

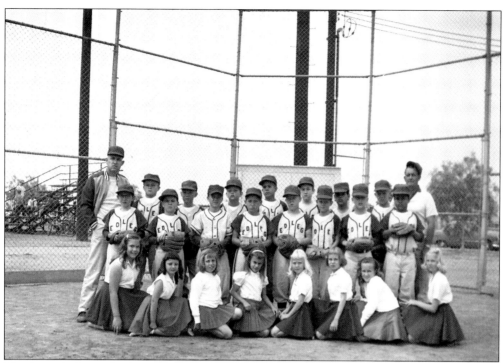

Members of a Sunset Little League team of 1961 pose for their team photograph with what appears to be their own cheerleading section of cute little girls. (Courtesy of the Bob Runnells family.)

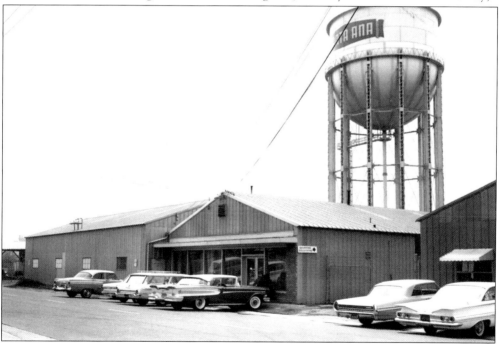

Honer Construction Company at 1424 Poinsettia Street is pictured in the shadows of the Santa Ana Water Tower. Allison Honer was the builder of many homes and other facilities in Santa Ana, including Honer Plaza, later renamed Bristol Marketplace. (Courtesy of Rob Richardson.)

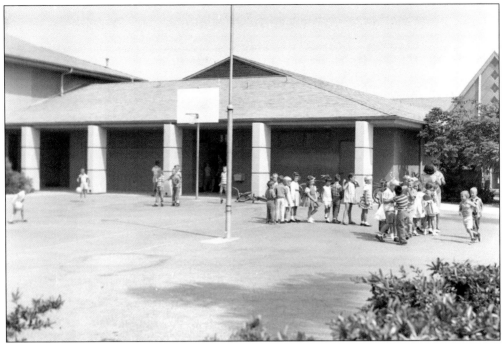

Bible school classes play in the playground outside of the Education Building and Fellowship Hall at First Christian Church in 1962. This part of the facility was located on the College Avenue side of the property. (Courtesy of the Bob Runnells family.)

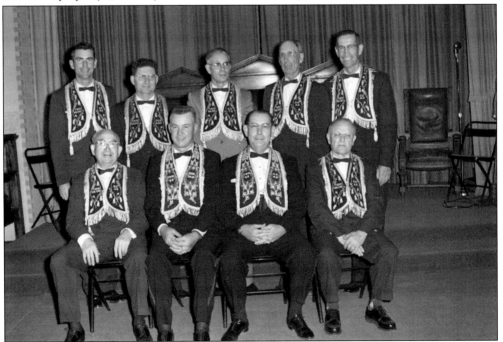

Officers from the Santa Ana chapter of the International Order of Odd Fellows pose for their installation photograph in 1961. Pictured standing on the left end is Bob Runnells, and on the right end is Alva "Hutch" Hutchinson. (Courtesy of the Bob Runnells family.)

This great facade of the Pepsi Bottling Company, located at 1420 West Fifth Street in June 1962, is a wonderful advertisement for the Pepsi brand. The property was acquired by the Santa Ana Unified School District in the late 1980s, and George Washington Carver Elementary School currently occupies the site. (Courtesy of Rob Richardson.)

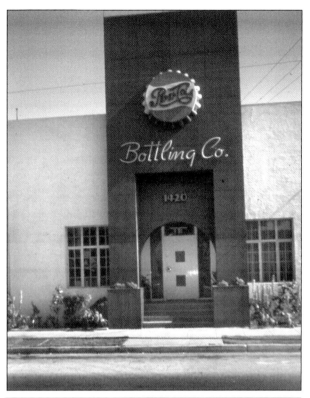

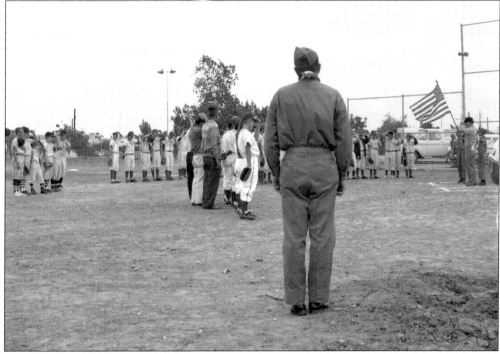

Teams in the West Santa Ana Pony League stand at attention for the Pledge of Allegiance prior to the start of their game in 1962. (Courtesy of the Bob Runnells family.)

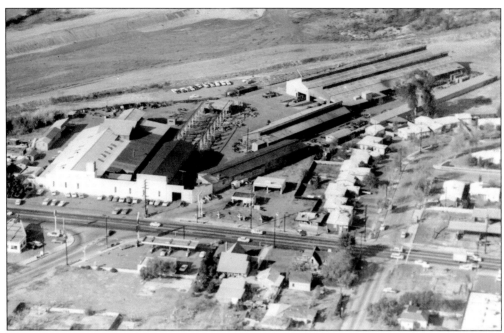

Above, a 1962 aerial view of Towner Manufacturing, located at 2111 West Seventeenth Street near the Santa Ana River, shows that there was very little development in the area at that time. Towner Manufacturing, originally located in downtown Santa Ana, was founded by Fred Towner, grandson of Judge James W. Towner. It was later purchased by George Sattler, a former partner in Gaffers and Sattler, and moved out to Seventeenth Street. Basil R. "Bill" Twist, Sattler's son-in-law, was president of the company from the 1950s until it was sold in 1986. Twist was a nephew of Nathan A. "Arch" Twist of the Lutz Company. The bottom photograph pictures a wheel-style trench manufactured by Towner in the 1960s. (Both courtesy of Basil R. Twist.)

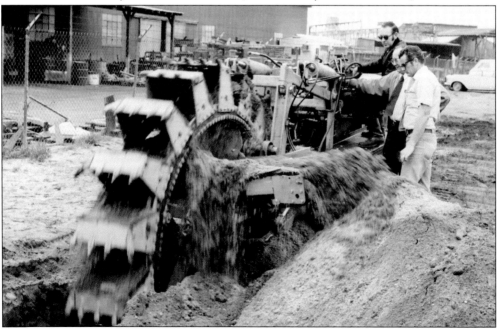

This is a view of Spurgeon Memorial Methodist Church in 1962. It was located at Broadway and Church Streets. This building was constructed in 1906. Established in 1870 as the first church in Santa Ana, it was later renamed Spurgeon Memorial in memory of Lottie Spurgeon, daughter of founder William Spurgeon, who died in a Laguna Beach drowning accident in 1890 at the age of 15. The church later relocated west of town on Memory Lane. Note the Dunton Ford sign to the left and behind the church. (Courtesy of the Orange County Archives.)

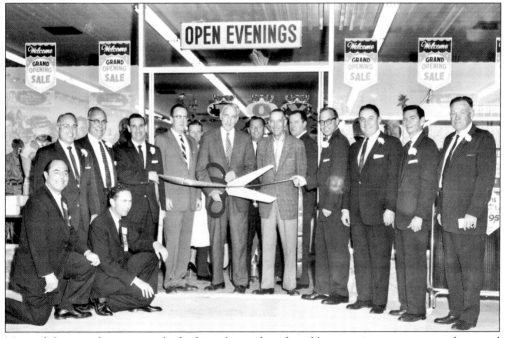

Most of the crowd appears to be looking forward to the ribbon-cutting ceremony at the grand opening of an unidentified store in the early 1960s. (Courtesy of Rob Richardson.)

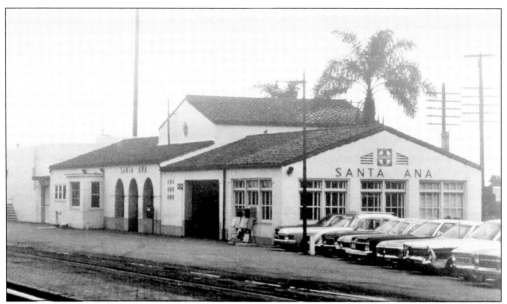

Santa Ana's second Santa Fe Depot was located at 1038 East Fourth Street. It closed on September 3, 1985, and was replaced by the Santa Ana Regional Transportation Center, located in essentially the same place, on September 4, 1985. (Courtesy of the Orange County Archives.)

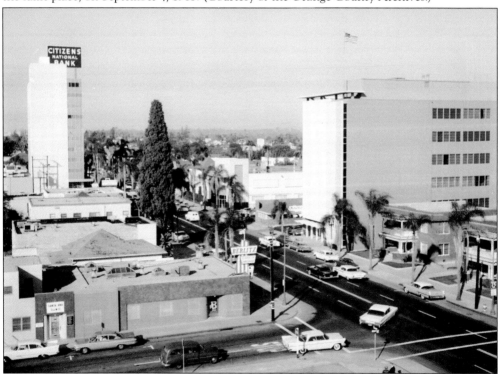

Broadway Street is pictured at Eighth Street, before the Civic Center Drive construction. The two 1920s apartment buildings at the right of the photograph were demolished around 2000. The Citizens Bank can be seen toward the north, and the building in the foreground is the Berlitz School of Languages. (Courtesy of the Orange County Archives.)

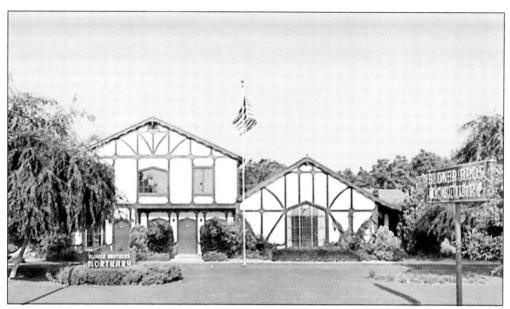

Blower Brothers Mortuary was located at 2525 North Main Street, across the street from where the Discover Science Center is located today. Another Blower brother, Elbert, who was known as "Duke," operated Blower Equipment Rentals. The mortuary's location occasionally resulted in some unfortunate mix-ups because of its proximity and similar name to Bowers Museum. (Courtesy of Nathan and Roberta Reed.)

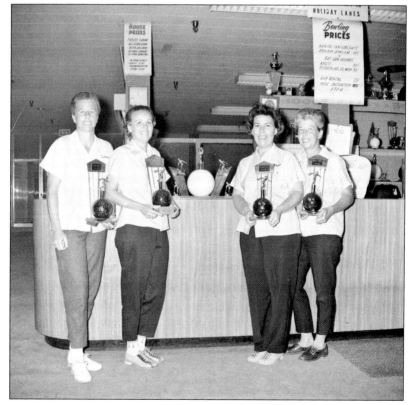

Members of the Coffee Cup Bowling Team show off their trophies. The team played at Holiday Lanes on West First Street. (Courtesy of the Bob Runnells family.)

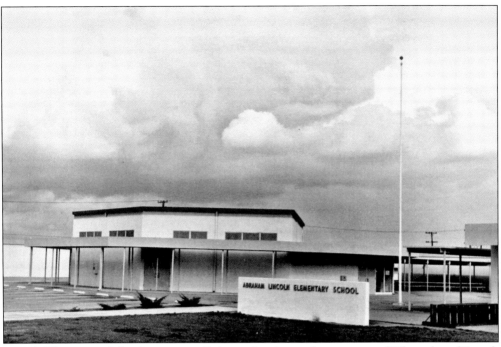

Lincoln Elementary School was originally located at the southeast corner of Fifteenth and French Streets. This facility later became the Santa Ana Unified School District office. The new school was located at 425 South Sullivan Street and was built in 1963. (Courtesy of Rob Richardson.)

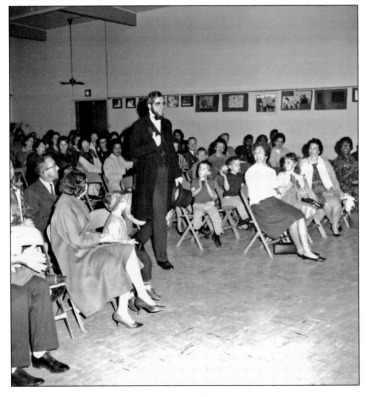

"Abraham Lincoln" visits Monte Vista Elementary School during their Founders Day Program in 1963. (Courtesy of the Bob Runnells family.)

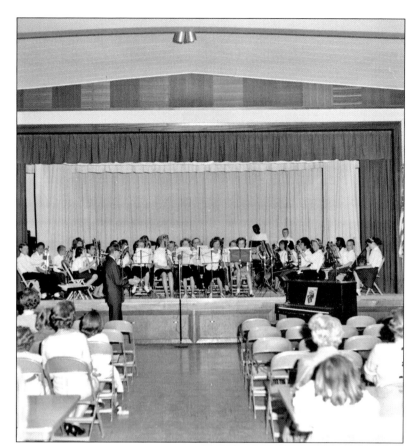

Monte Vista Elementary School had a sizeable music program in the 1960s. Both the choir and band are shown here performing in the school auditorium. (Both courtesy of the Bob Runnells family.)

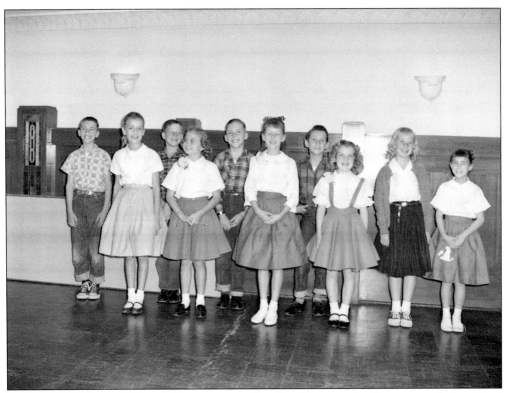

A group of Sunbeam Girls and their partners take a break to pose for the cameras during Good Fellowship night at the Odd Fellows Lodge. The children were entertaining the adults with their square-dancing skills that evening. (Courtesy of the Bob Runnells family.)

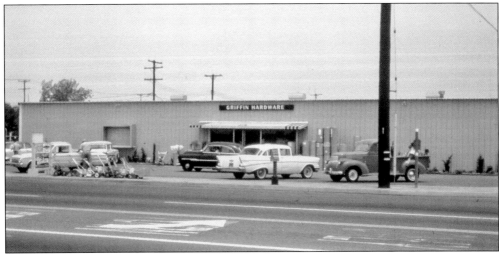

Griffin's Ace Hardware, located on West First Street, was originally known as Griffin's Hardware and Feed and has been a family-owned Santa Ana business for more than 50 years. They started out selling chicks and feed, later becoming an Ace Hardware Store. (Courtesy of Rob Richardson.)

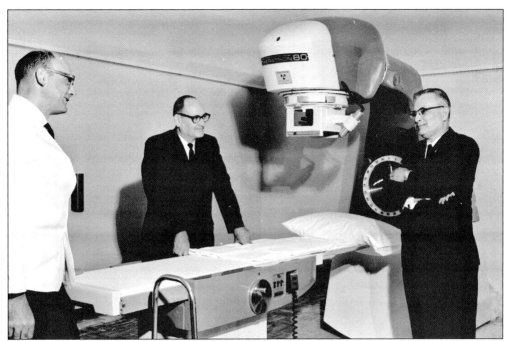
Cobalt-60 radiation began to be used as a form of cancer treatment in the 1950s. Pictured here is the Theratron 80 cobalt machine used in the Radiological Unit of Santa Ana Community Hospital. The photograph dates to March 25, 1964. (Courtesy of the Robert Geivet Collection, Old Courthouse Museum.)

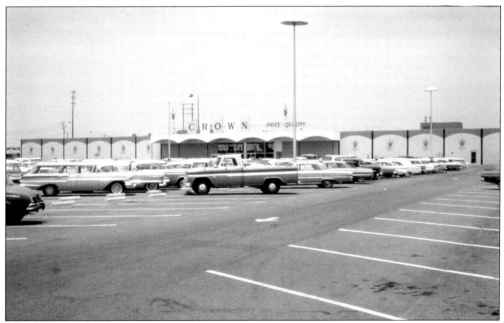
Crown Store was quite busy in June 1964, when this photograph was taken. Located on the northeast corner of Warner Avenue and Harbor Boulevard, the store was closed in the early 1970s and the building was later occupied by Collins Electronics, based in Cedar Rapids, Iowa. Competitors of Crown would be White Front, Fedco, and others. (Courtesy of Rob Richardson.)

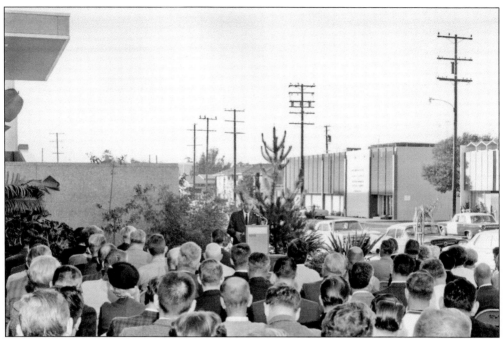

Supervisor Cecil M. "Cye" Featherly speaks at the dedication of the new county finance building in 1964. Featherly was a member of the board of supervisors from 1949 to 1968, and Orange County's Featherly Regional Park was named after him. (Courtesy of the Orange County Archives.)

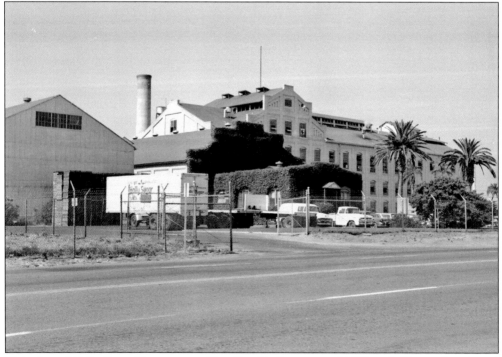

This view of Holly Sugar Company on Dyer Road is from around 1965 and offers a nice view of the historic processing facility. (Courtesy of the Orange County Archives.)

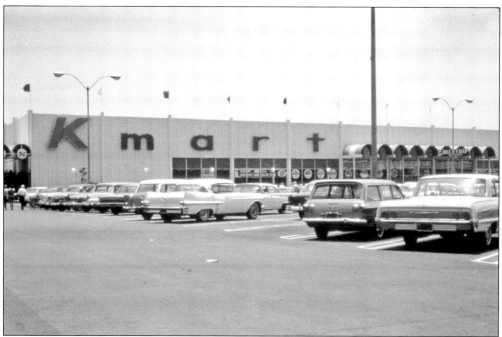

This K-Mart store, shown here in June 1964, was located in the shopping center on the southwest corner of Bristol Street and Edinger Avenue, across the street from Mater Dei High School. A sign in the doorway proclaims that the store gives away Blue Chip Stamps. A Thrifty Mart and Thrifty Drug Store were also located in the same shopping center. (Courtesy of Rob Richardson.)

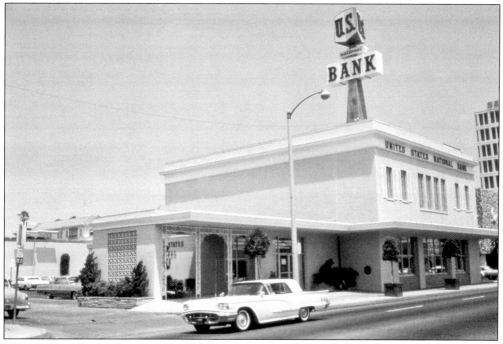

U.S. National Bank, also shown in 1964, was located at 700 North Main Street. California Coast University is now located at that site. (Courtesy of Rob Richardson.)

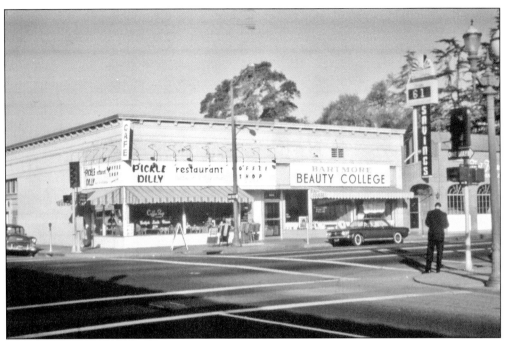

In December 1964, the northwest corner of Broadway and Fifth Streets was home to the Pickle Dilly Coffee Shop, which according to its sign was "famous for its pastrami." The Bartmore Beauty College is next door. (Courtesy of Rob Richardson.)

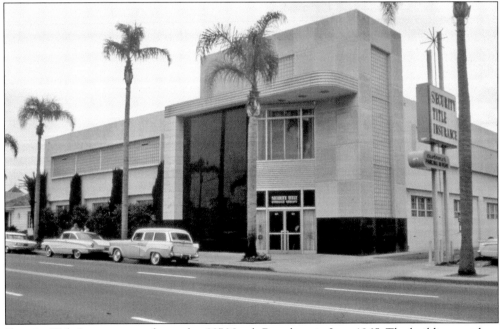

Security Title Insurance was located at 827 North Broadway in June 1965. The building, modern for the time, was architecturally quite pleasing. It later became Safeco Title Insurance and finally was the building occupied in the 1990s by Hermandad Nacionale. (Courtesy of the Orange County Archives.)

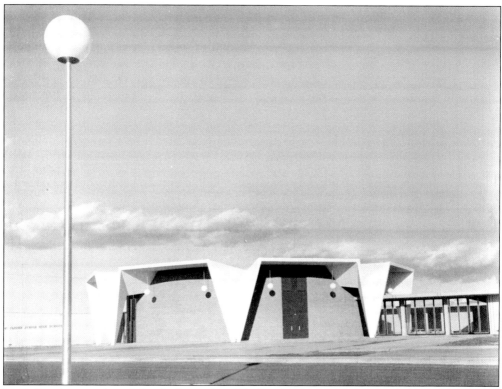

McFadden Intermediate School is located at 2701 South Raitt Street and was known as McFadden Junior High School when it was constructed in the mid-1960s to accommodate the growing residential population on the southwest end of town. (Courtesy of Rob Richardson.)

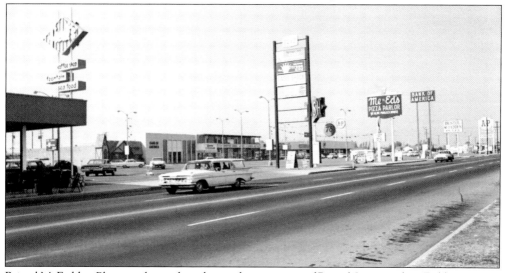

Bristol McFadden Plaza was located on the southwest corner of Bristol Street and McFadden Avenue and extended south to approximately Wilshire Avenue. In this 1965 photograph, stores located there included Me 'n Eds Pizza, Radio Shack, Bank of America, the A&P Market, and Fredi's Coffee Shop. Pence Pharmacy and Seeley's Bakery were two longtime family-owned businesses that were also located there. (Courtesy of the Santa Ana Public Library History Room.)

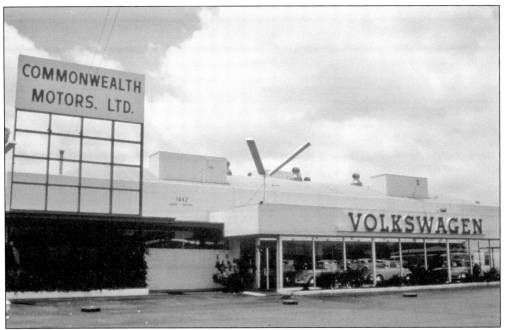

Commonwealth Motors, Ltd., located at 1442 South Bristol Street (at Edinger Avenue) in 1965, was a Volkswagen dealership that must have contributed greatly to the population of Volkswagen Beetles in Santa Ana. Now known as Commonwealth Volkswagen-Audi, the business is located in the Santa Ana Auto Mall. (Courtesy of Rob Richardson.)

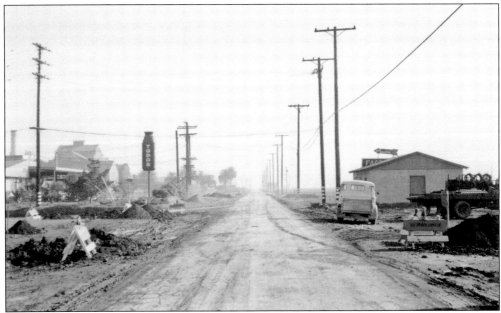

Dyer Road in 1965 was just a dirt road. Holly Sugar can be seen in the distance on the left. An arrow on the right side of the picture, pointing to the left, with the words "now building" indicates development coming to the area in the near future. In a few short years, the area would be built up enough that the city would add a fire station nearby on Grand Avenue (formerly known as McClay Street) to service these new industries. (Courtesy of the Orange County Archives.)

Farmers Insurance's regional office, built in 1957, was located at 2800 Farmers Drive near Flower Street and the 5 Freeway. The site became a center of controversy when the Santa Ana Unified School District obtained the site and proposed to build a school at the location. Eventually the property was sold to Shea Homes, and residential housing was constructed there. (Courtesy of Rob Richardson.)

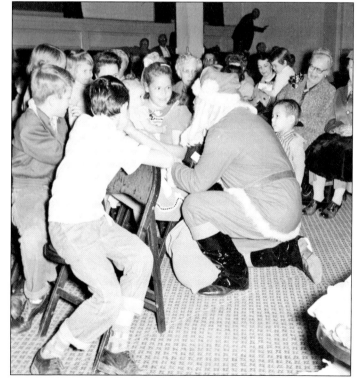

Santa Claus holds the attention of the good little boys and girls at the International Order of Odd Fellows Christmas party as he delivers gifts to them. The party was held at the Odd Fellows Hall on Main Street, and the children attending are the children and grandchildren of lodge members, who are obviously entertained by the scene. (Courtesy of the Bob Runnells family.)

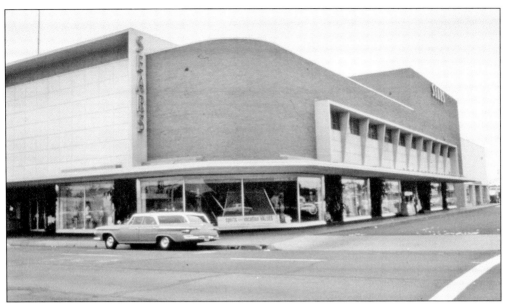

Originally located in downtown Santa Ana, the Sears Department Store was later relocated to 1716 South Main Street. Shown here in June 1965, it would be only a few short years before another, larger Sears Store would open at South Coast Plaza a few short miles away. Though the two stores coexisted for many years, with the South Main store operating largely as an outlet and catalog store in later years, eventually this store was closed. A Superior Warehouse Store now sits on this site. (Courtesy of Rob Richardson.)

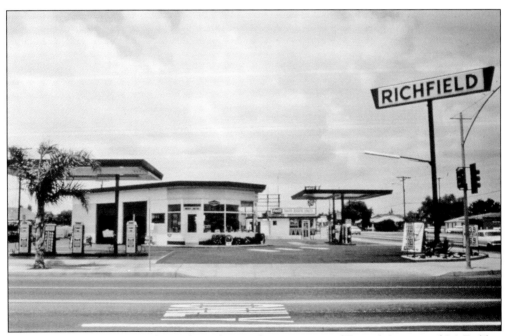

This Richfield Station was located on the northwest corner of Bristol Street and McFadden Avenue, across the street from Bristol McFadden Plaza. In some ways, the station looks a lot like those of today, but the gas pumps seen here are vintage 1965. (Courtesy of Rob Richardson.)

Seen here is North Main Street in 1966, looking north in the 800 block. Numerous title companies and financial institutions were located in this area at this time. The smaller building south of the Security Bank building houses a title insurance company, and United California Bank (UCB) and The Travelers share the same building to the north. (Courtesy of Rob Richardson.)

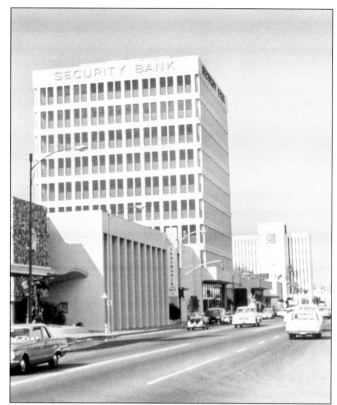

The intersection of Tustin and Seventeenth Streets is shown in 1966. Walkers Market, shown on the left, was in business in this location for many years before going out of business in the 1980s. On the right side of the photograph are Armstrongs Nursery and the branch Security Bank building, next to the Auto Club office. (Courtesy of the Orange County Archives.)

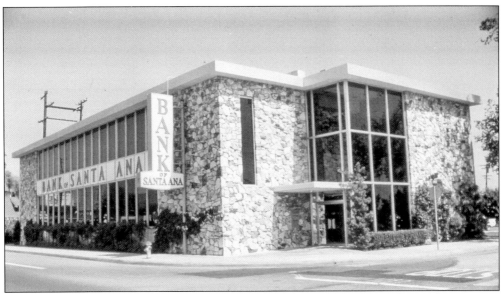

The Bank of Santa Ana was located at 1200 West Seventeenth Street, on the southeast corner of the intersection with Bristol Street. Now a major intersection, in 1966, it was controlled with a stop sign. Today the building is occupied by a dental office. (Courtesy of Rob Richardson.)

This 1966 photograph of Bristol Street and MacArthur Boulevard was a bit of a mystery without the help of some old maps. It is not at the same location as the Bristol and MacArthur we know today. Rather, this intersection is approximately where the intersection of Bristol Street and Jamboree Road is now located. While not strictly in Santa Ana, at that time, the area was associated with Santa Ana since it was the closest city to this undeveloped area. The sign at the intersection says Santa Ana is seven miles to the north. The other sign says that this is near the County Disposal Station. (Courtesy of the Orange County Archives.)

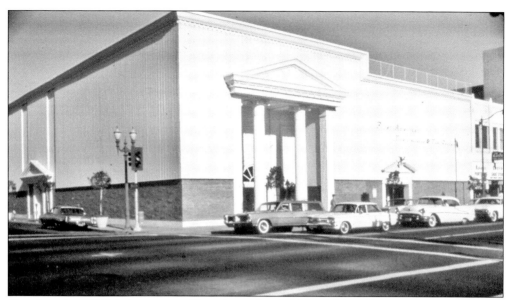

First American Title's downtown offices, located at 421 North Main Street, are pictured in July 1966. If one looks carefully at this building, one will discover the old moderne-styled Orange County Title Building under this remodeled facade. (Courtesy of Rob Richardson.)

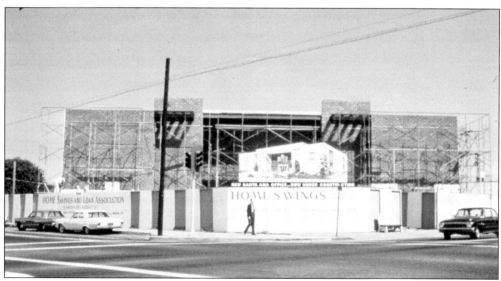

The Home Saving and Loan facility at Main Street and Washington Avenue was constructed in 1966. Home Savings was always famous for the artwork shown on their buildings, and this one was no exception. The picture shown on the billboard does very closely resemble the finished product. Home Savings was purchased in later years by Washington Mutual, which operates this facility today. (Courtesy of Rob Richardson.)

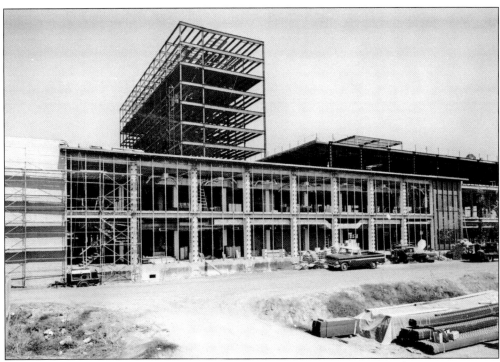

Construction began on the new Orange County Courthouse, still in use today, in 1967. It was designed by world-renowned architect Richard Neutra and cost $22 million to build. The dedication ceremony was January 10, 1969, following the closure of the Old Courthouse on December 13, 1968. (Courtesy of the Orange County Archives.)

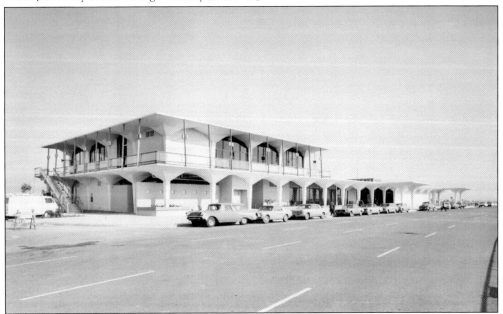

The original passenger terminal at the Orange County Airport opened in 1967. At that time, Air California began nonstop service to San Francisco using two turbo-prop Lockheed L-188 Electras. (Courtesy of the Orange County Archives.)

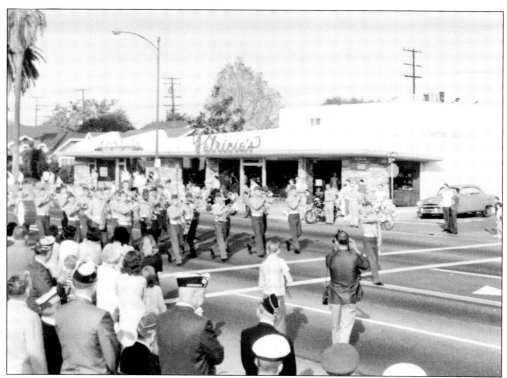

A military band takes part in the Veterans Day Parade, marching down Main Street in November 1967. (Courtesy of the Orange County Archives.)

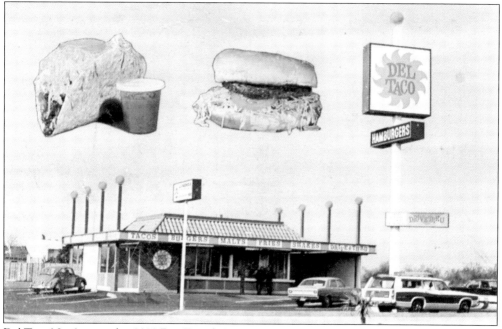

Del Taco No. 9 opened at 2320 East Fourth Street in December 1969 and continues to be a popular fast-food destination today. It's too bad the reminiscent bright oranges could not be reproduced in this book. (Courtesy of the Orange County Archives.)

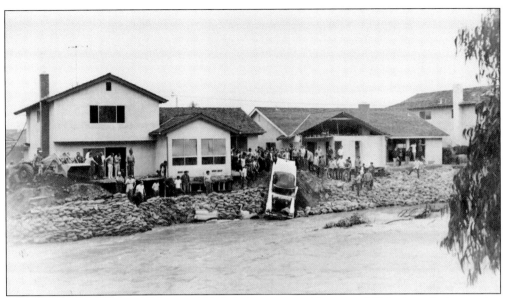

Heavy rains in January and February 1969 left the county with a record 21 inches of rain, causing severely swollen creeks and flood control channels to overflow their banks. This February 26, 1969, photograph gives a glimpse of the damage to properties along Santiago Creek. Houses and swimming pools were damaged, and some backyards were completely lost. The photograph also tells of the community volunteerism, as many turned out to fill and lay sandbags or help neighbors in whatever way they could. (Courtesy of the Santa Ana Public Library History Room.)

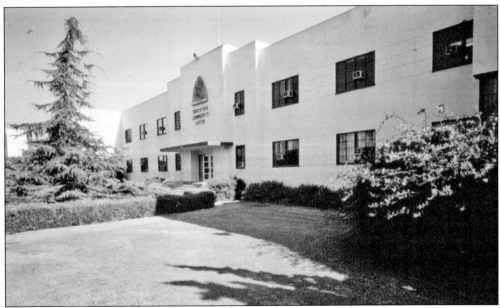

The Santa Ana Community Center faced Eighth Street at a location approximately where the Santa Ana Police Department headquarters is located today. It was built during World War II and used as an administrative building for the U.S. Army Air Corps. It was used as a community center by several organizations over the years until it closed in the late 1960s, after which it was used by the Santa Ana Fire Department for training. (Courtesy of Rob Richardson.)

Four
1970–1979

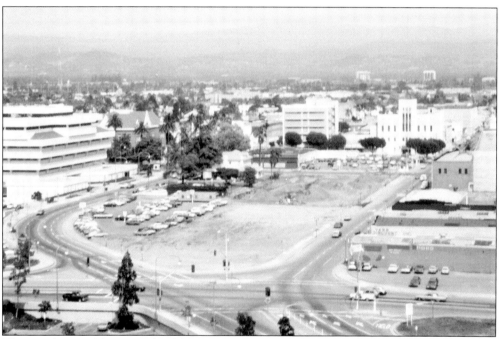

This aerial view of the west side of the Civic Center shows the new county Hall of Administration on the left, with the Old Courthouse right behind it. On the far right is the Masonic Temple. The small building among the trees to the left of center is the Crane House, at that time occupied by the Smith-Tuthill-Lamb Mortuary. All the undeveloped land in this photograph, including the parking lot to the east of the Masonic Temple, is now home to office buildings and parking structures, including the Orange County Transportation Authority (OCTA) Transportation Center. (Courtesy of Rob Richardson.)

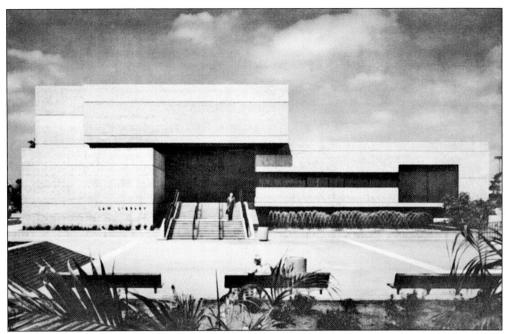

The very modern-looking Orange County Law Library was designed by architects Allen and Miller as part of the new Civic Center construction. It is located at 515 North Flower Street. (Courtesy of the Orange County Archives.)

This scene of the interior courtyard of the Bowers Museum portrays it as the local history museum that it was at the time of its inception in 1936 until the mid-1980s. At that time, Bowers closed for major remodeling and reopened in 1992 as the Bowers Museum of Cultural Art. (Courtesy of Rob Richardson.)

Project SOAR (Save Our American Resources) was initiated in 1971 by the Boy Scouts of America as a conservation effort. Here Santa Ana Boy Scouts collect bottles to recycle as part of that effort. (Courtesy of the Orange County Archives.)

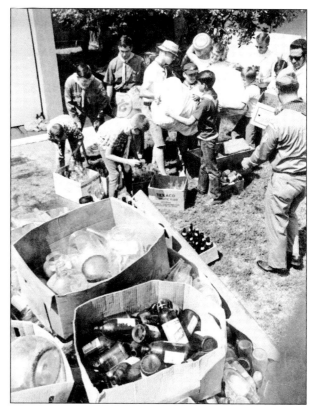

The Sierra Elementary School choir performs at an event at the First Presbyterian Church in 1971. Margaret Lehman (right) was the director; Jane Newcomer (left) was the choir's accompanist. (Courtesy of Rob Richardson.)

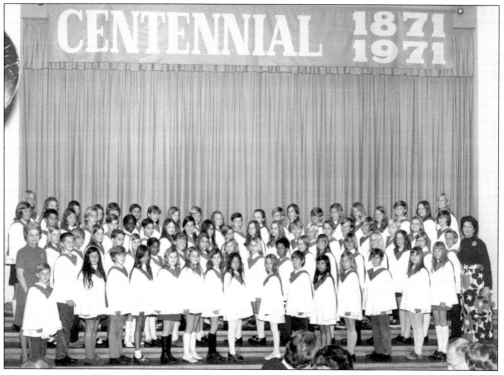

Golden West Mobile Home Manufacturing was located at 1929 East St. Andrews Place. The company relocated to the Inland Empire in 1982–1983; the facility houses an O'Neill Storage facility today. (Courtesy of Rob Richardson.)

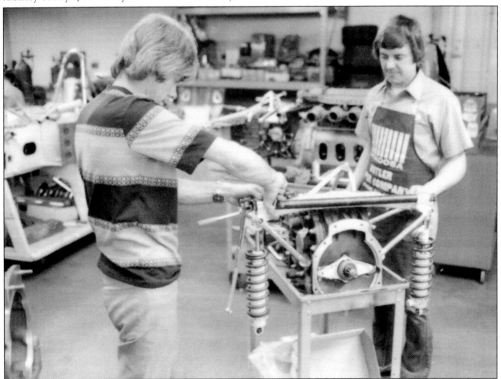
Employees at All American Racing work on the manufacture of a race car destined for the Indianapolis 500. All American Racing was begun in Santa Ana in 1965 by Dan Gurney and Carroll Shelby. Dan Gurney continues to be chairman and CEO of the company today. (Courtesy of Rob Richardson.)

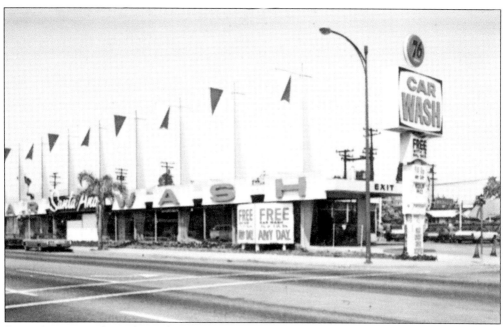
Santa Ana Carwash was located at 1807 North Main Street. The facility still exists today as Main Street Car Wash. (Courtesy of Nathan and Roberta Reed.)

A firearm safety class in the 1970s is of interest to both men and women. (Courtesy of Rob Richardson.)

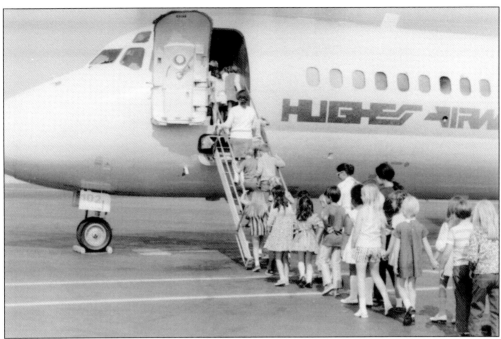

A group of schoolchildren boards a Hughes Airwest airplane at the Orange County Airport as part of a tour in 1972. (Courtesy of the Orange County Archives.)

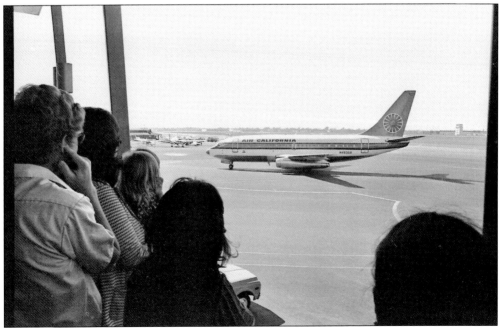

An Air California plane lands at Orange County Airport and approaches the terminal, observed by the waiting crowd. At this time, passengers disembarked from the stairs out onto the runway, and anyone on hand to meet them also waited outside. It apparently got very loud out there, as noted by the lady on the left who is attempting to block the noise by plugging her ears. (Courtesy of Rob Richardson.)

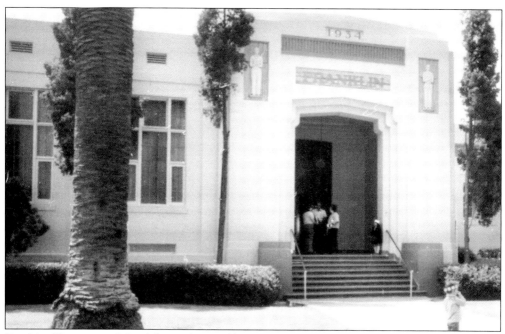

Franklin Elementary School, located on Cubbon Street between Broadway and Sycamore Streets, was built in 1934 as Spurgeon Elementary School and was designed by Frederick Eley. Spurgeon was closed in the early 1970s as a result of decreased enrollment and reopened in 1975 as Franklin Fundamental School, the first fundamental school in Santa Ana. The school was renamed because, during its closure, a new intermediate school had opened and been named Spurgeon. (Courtesy of Rob Richardson.)

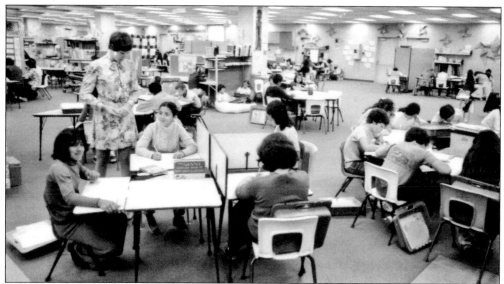

An open-style classroom at Wilson Elementary School is shown. In the 1970s, many Santa Ana schools began using "modern" styles of education, such as class sharing and open classrooms. Many of the older schools had walls torn down between classes to accommodate this. In the case of Wilson, it was planned for during new construction following the 1971 earthquake. (Courtesy of Rob Richardson.)

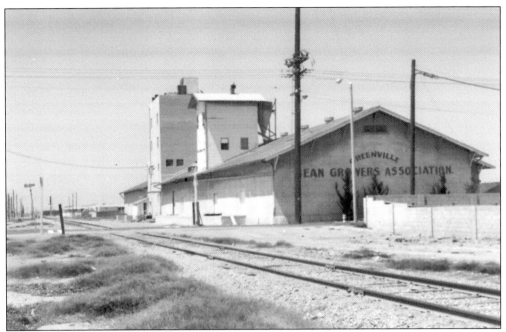

The Greenville Lima Bean Growers Association erected this packinghouse in 1918, and it continued to be used until the 1980s. Pictured here in 1973, it was eventually sold to C. J. Segerstrom and Sons. (Courtesy of the Orange County Archives.)

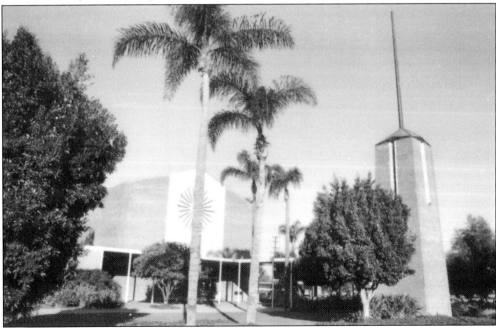

First Baptist Church was organized in March 1871. The first church building was constructed at Main and Church Streets in 1876. A second, larger building was constructed at the same location in 1913–1914. In the 1950s, First Baptist, like many other downtown churches, moved out to the "edge" of town. The current building, shown here in the 1970s, is located at 1010 West Seventeenth Street. (Courtesy of Rob Richardson.)

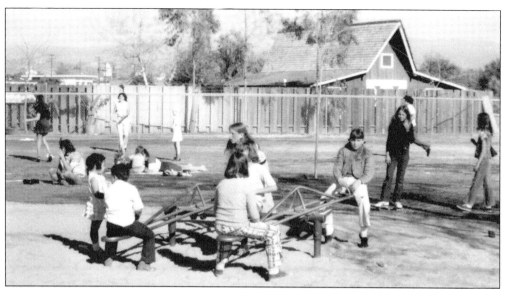

In 1949, J. E. Prentice donated 12 acres of his citrus ranch to the City of Santa Ana for a park, with the stipulation that at least 50 monkeys must be kept at the park at all times. Shown here in the 1970s, Prentice Park was still mostly a park with a zoo connected to it. Over the years, it has grown and expanded into a very respected small zoo with a fine collection of animals. (Courtesy of Rob Richardson.)

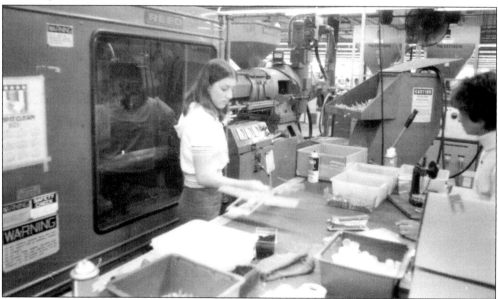

L. M. Cox Manufacturing was founded in 1945 by Roy Cox. Working out of his garage in Placentia, the company first produced only wooden pop guns. When metal began to become readily available again after World War II, he expanded to include push cars and cast-aluminum midget racers. He relocated to a manufacturing facility at 1505 East Warner in 1963. The company was sold to Leisure Dynamics in 1969 and continued to grow with the acquisition of Airtronics, Inc. By the 1990s, it had outgrown all available space in Santa Ana and moved to a larger manufacturing facility in Corona. Here two women are working on a manufacturing line at the Warner Avenue facility. (Courtesy of Rob Richardson.)

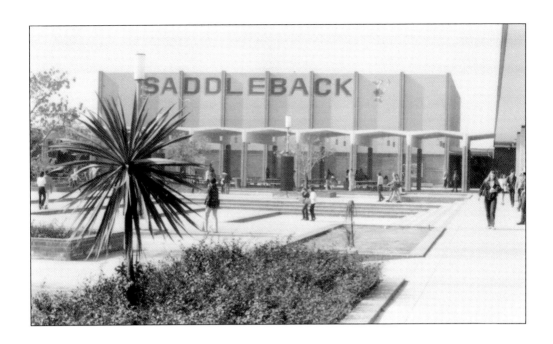

Saddleback High School opened in 1967 to serve a growing population in South Santa Ana. It was the third high school to serve the city. These 1970s photographs show (at top) the main quad at the school and (at bottom) the computer lab. Note that the students are working on terminals that will feed into a mainframe computer, very different from the personal computers used today. (Both courtesy of Rob Richardson.)

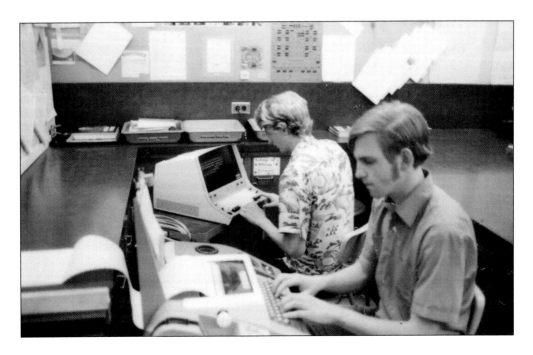

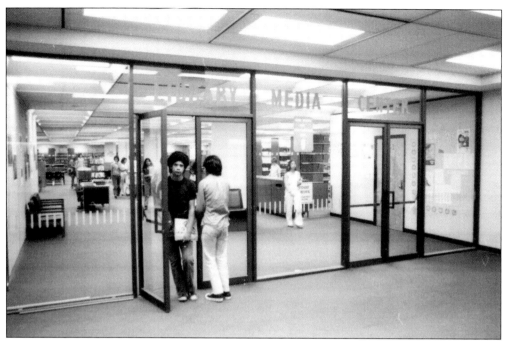

The library at Santa Ana High School, more commonly known as the "media center" in the 1970s, is shown. Like many school facilities at that time, it had been remodeled to a very open feel, with lots of glass-plate doors and windows. (Courtesy of Rob Richardson.)

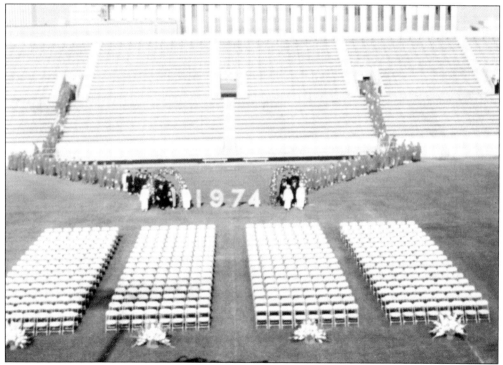

Santa Ana High School class of 1974 processes into the Santa Ana Bowl (now Eddie West Field) for their graduation ceremonies in June 1974. (Courtesy of Sherry and Randy Williams.)

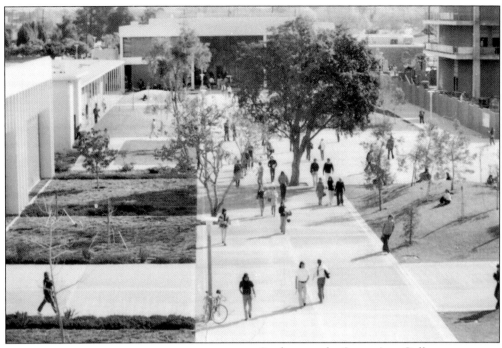

Students at the Santa Ana College campus at Seventeenth and Bristol Streets make their way to their next class. The college was begun in 1915 as a branch of Santa Ana High School; classes were first held at this campus in 1947. (Courtesy of Rob Richardson.)

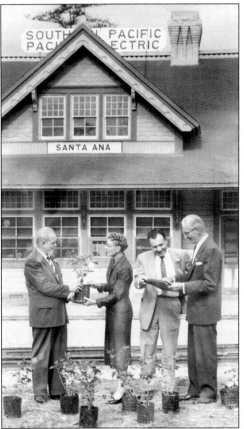

Adeline Walker (Mrs. Weston Walker), an avid gardener and preservationist, helps plant trees at the Southern Pacific Station. Walker was involved in the Santa Ana Garden Club for many years and was a leader for local youth gardening groups. (Courtesy of Rob Richardson.)

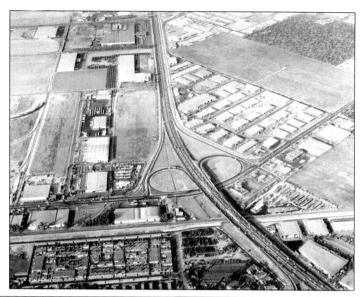

This aerial view shows the 55 Freeway at Edinger Avenue, looking south, in 1974. Significant industrial development has taken place in the area since this photograph was taken. The on ramps and off ramps were unchanged until very recently, when both were reconfigured. (Courtesy of County of Orange, Resources and Development Management Department.)

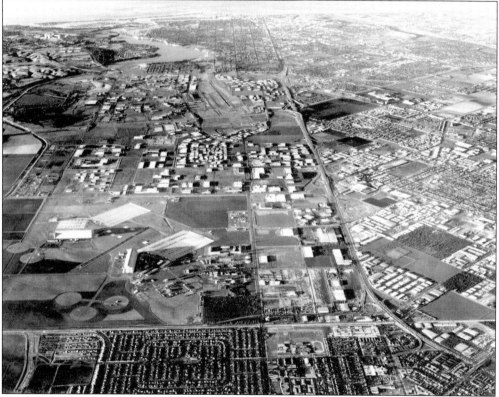

This aerial shot, from a higher elevation, shows the 55 Freeway looking south from Edinger Avenue down to MacArthur Boulevard. It shows that by 1974, while there is still significant open space, much of the area has been developed. A lot of the open space is part of the Tustin Marine Corps Air Station, formerly the Santa Ana Army Air Base. The two blimp hangers can be seen in the left center of the photograph. (Courtesy of County of Orange, Resources and Development Management Department.)

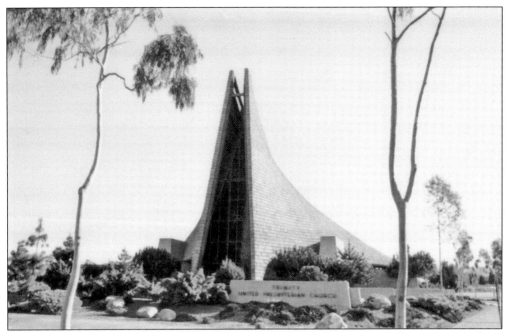

Trinity United Presbyterian Church was the first United Presbyterian church founded in Southern California. It was organized on June 22, 1876, in the home of James McFadden. The church's first sanctuary was built on the northwest corner of Fourth and Mortimer Streets. They later relocated to the northwest corner of Sixth and Bush Streets and finally moved to the current location, at 13922 Prospect Avenue, in 1962. Rev. Don Moomaw, son-in-law to Herman and Virginia Basler, was a guest speaker at the last service at the Sixth and Bush location. (Courtesy of Rob Richardson.)

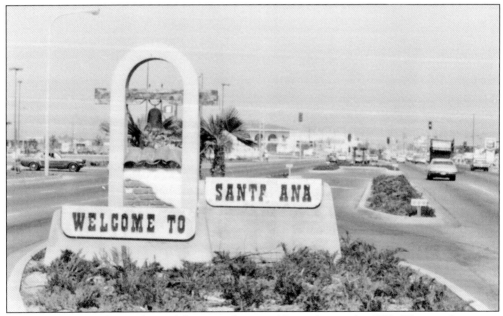

Mission-themed markers welcomed drivers to the city of Santa Ana in the 1970s. The one shown was located on Bristol Street just south of MacArthur Boulevard. (Courtesy of Rob Richardson.)

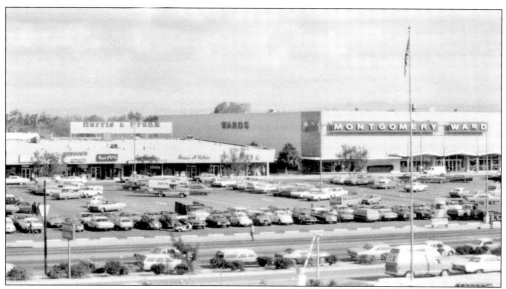

By the 1970s, construction at Honer Plaza Shopping Center was completed and it was a busy shopping mall. It is pictured here as seen from Santa Ana College, across Seventeenth Street. (Courtesy of Rob Richardson.)

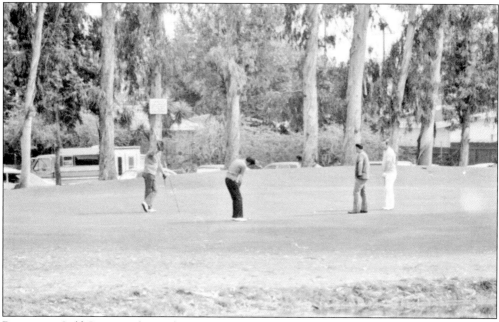

Riverview Golf Course is located at 1800 West Santa Clara Avenue. Not only does the course provide a view of the river, but part of the course is actually in the Santa Ana River bed. Designed by David W. Pfaff, the course opened in 1970. (Courtesy of Rob Richardson.)

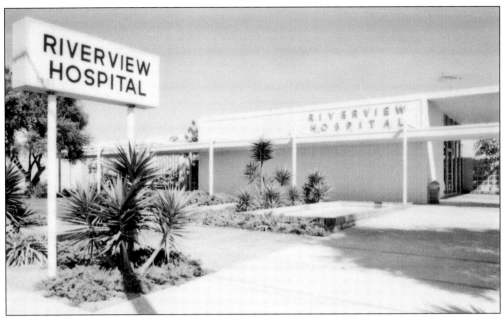

Riverview Hospital was located at 1901 North Fairview Street. Like many other hospitals at the time, it was closed in the late 1990s because of rising health care costs. (Courtesy of Rob Richardson.)

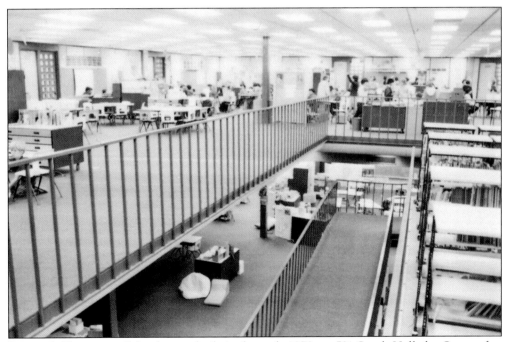

Roosevelt Elementary School was rebuilt in the early 1970s at 501 South Halladay Street after the First Street facility was closed following the 1971 Sylmar earthquake. The new construction also featured the open feel of many other schools constructed at that time. (Courtesy of Rob Richardson.)

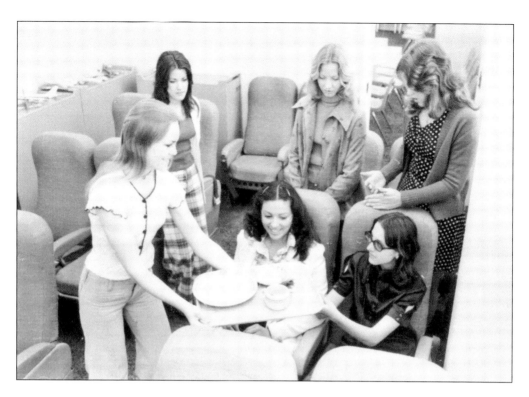

Some of the courses available at Santa Ana College in the 1970s were a little unusual by today's standards. In the top photograph, students take a course in stewardess training. The bottom photograph shows a course in restaurant business. (Both courtesy of Rob Richardson.)

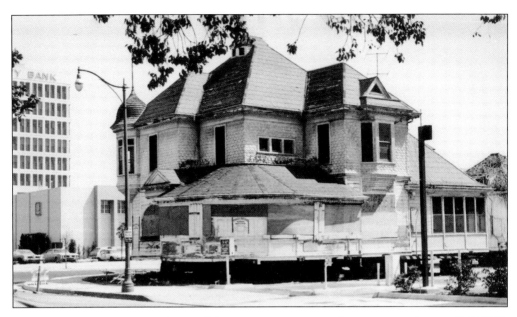

The Dr. Howe-Waffle House, home of the Santa Ana Historical Preservation Society (SAHPS), was moved to the present location at Sycamore Street and Civic Center Drive in 1975 to save it from demolition. The photograph at top was taken shortly after the move was completed, before foundation work was done. The bottom photograph shows a group at the house, standing in front of the Civic Center door, around the same time. Adeline Walker, founder of the Santa Ana Historical Preservation Society, is in the center. In the back behind Walker is Connie Becker, a Waffle baby (delivered by Dr. Waffle) who was also involved in the restoration and on the SAHPS board for many years. (Both courtesy of the Orange County Archives.)

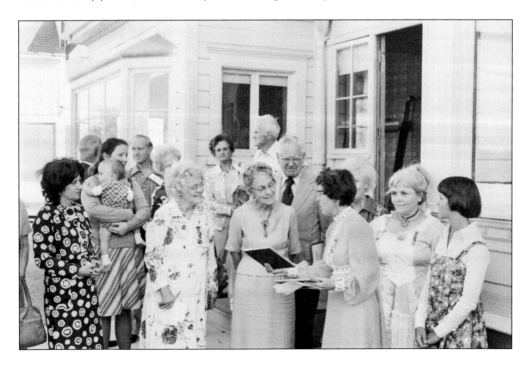

Adeline Walker is shown standing in front of the fireplace in the back parlor of the Dr. Howe-Waffle House during restoration. A slight glimpse of the amount of work needed on the house can be seen. The fireplace was probably newly installed at this point, as it was not original to the house. Originally located in the French Mansion, which was demolished in the 1960s to make room for a parking lot at Buffums' Department Store, the fireplace was donated to replace one that was missing in the Howe-Waffle House. (Courtesy of the Orange County Archives.)

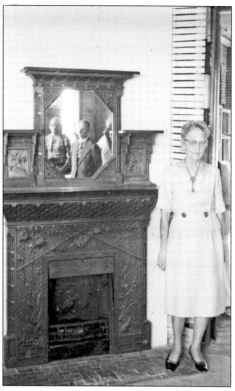

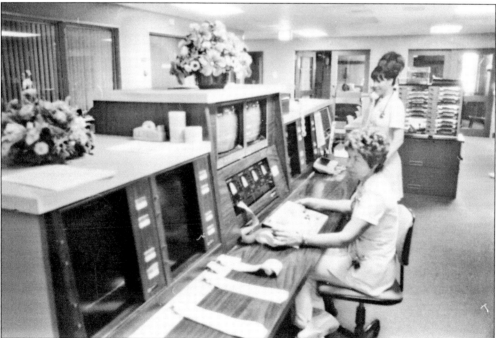

Nurses work in the emergency room at Santa Ana Community Hospital during the 1970s. While computers were beginning to come into use at this time, it is quite "low tech" compared to today. (Courtesy of Rob Richardson.)

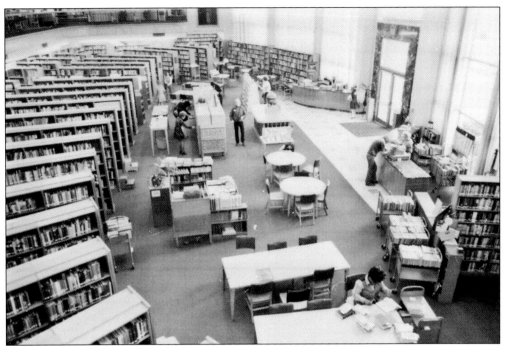

The main floor of the Santa Ana Public Library is seen from the second-floor balcony. While the layout of the library has not changed significantly in recent years, the front entrance, shown here, is no longer in use, and the checkout table has been moved to the back of the library. (Courtesy of Rob Richardson.)

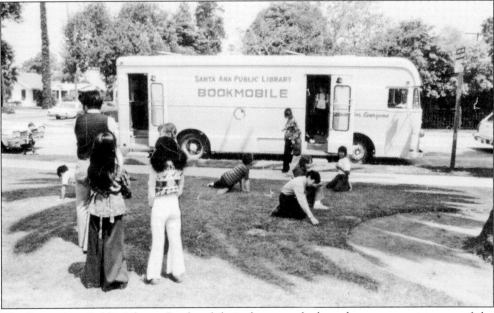

The Santa Ana Public Library Bookmobile is shown parked on the street next to one of the elementary schools. The bookmobile was established to provide library services to children and others who may not otherwise be able to go to the library. Bookmobile services were begun in 1961 in Santa Ana; they were discontinued in 2006. (Courtesy of Rob Richardson.)

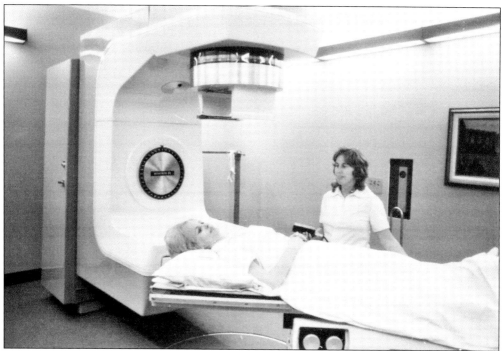
Radiation therapy is demonstrated at Santa Ana Tustin Community Hospital, which later became Western Medical Center. (Courtesy of Rob Richardson.)

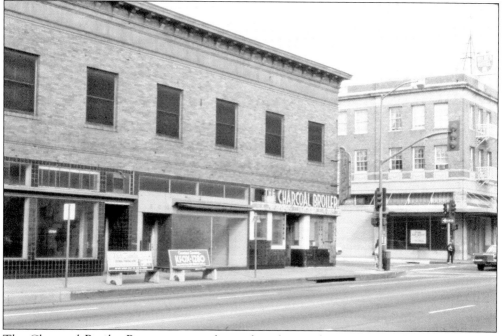
The Charcoal Broiler Restaurant was located at the southwest corner of Sixth and Main Streets. After doing business at that site for around 30 years, it closed in the 1960s and the building was demolished in 1975. The Ralph Allen Architects building replaced it. (Courtesy of Rob Richardson.)

The interior court of the MacArthur Village Apartments on MacArthur Boulevard between Flower and Bristol Streets appeared to provide some nice amenities for apartment dwellers. The apartments have since been converted into condominiums. (Courtesy of Rob Richardson.)

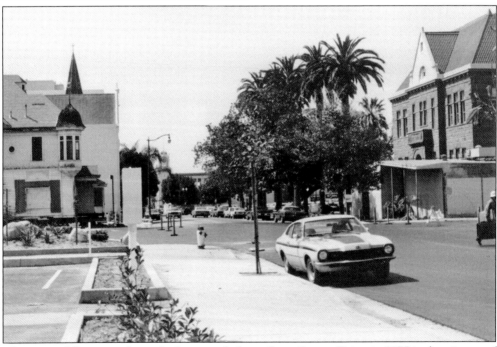

This view of Sycamore Street looking south from Civic Center Drive in 1975 is the picture of restoration in progress. The Dr. Howe-Waffle House has been moved and awaits restoration, and the Old Courthouse, across the street, also has some activity. Both were eventually fully restored, largely through the efforts of Adeline Walker, a tireless, dedicated preservationist. (Courtesy of the Orange County Archives.)

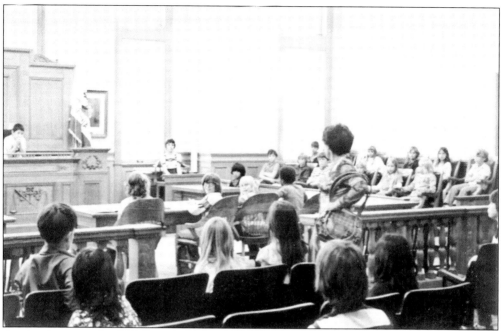

A school tour at the Old Courthouse in 1976 shows children what court was like in Orange County in the early part of the 20th century. Both courtrooms were eventually restored as part of the Old Courthouse Museum, one as a faithful reproduction of what is was like in early years and the other as an exhibit room. (Courtesy of the Orange County Archives.)

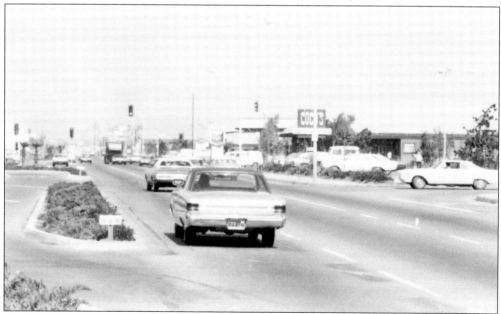

The scene at south Bristol Street looking north just above Sunflower Avenue has not changed that much since this photograph was taken in the 1970s, although some of the businesses have changed. Only a short time before this photograph was taken, much of south Bristol was planted in bean fields rather than strip malls. Once development started, it took hold rapidly in this area. (Courtesy of Rob Richardson.)

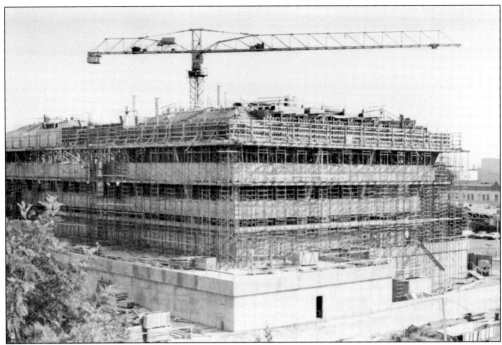

The Orange County Hall of Administration was constructed in 1977–1978 at Santa Ana Boulevard and Broadway Street. The site was formerly occupied by the First Christian Church and the St. Ann's Inn. (Courtesy of Rob Richardson.)

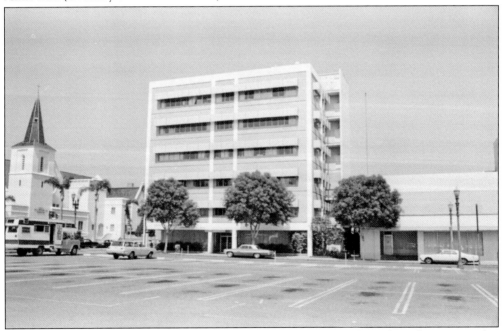

As Orange County grew, it branched out into many office buildings throughout downtown. This building at the corner of Santa Ana Boulevard and Sycamore Street, right across from the First Presbyterian Church, served as the county Hall of Administration from 1964 to 1978, when the present building was completed. (Courtesy of the Orange County Archives.)

Five
1980–2007

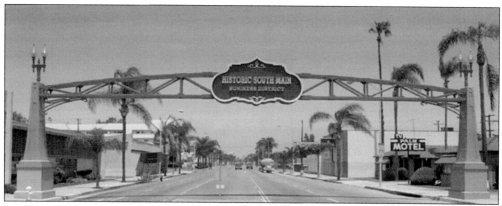

In 2007, the city erected a new sign on Main Street, looking north just above Warner Avenue, identifying the area as the Historic South Main Business District. The sign is reminiscent of the one that once welcomed visitors to Santa Ana as they entered off Highway 101 on the northwest edge of town. (Courtesy of the City of Santa Ana Planning Department.)

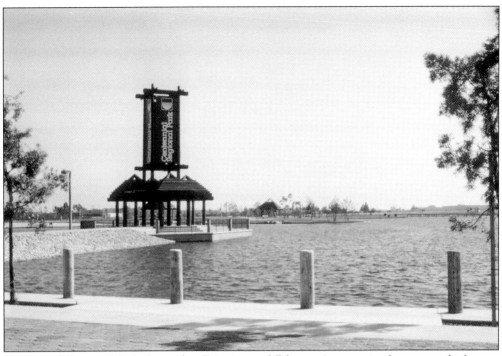

Centennial Regional Park, located at Fairview and Edinger Avenues in the west end of town, comprises 87 acres and offers playgrounds, soccer and softball fields, barbecue facilities, and a lake stocked with fish, as well as biking trails. This photograph of the park was taken shortly after it opened in 1980. (Courtesy of the Orange County Archives.)

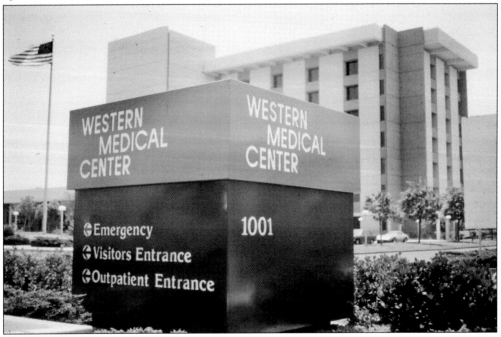

Santa Ana Tustin Community Hospital, located at 1001 North Tustin Avenue, later became known as Western Medical Center. It is pictured here in 1980. (Courtesy of Rob Richardson.)

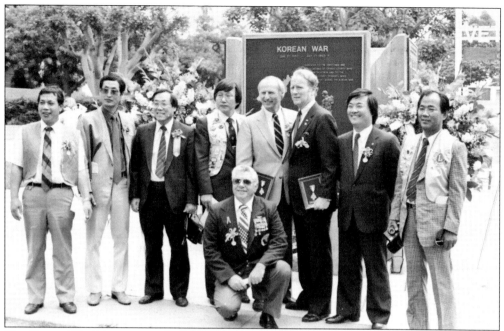

The Korean War Monument is located in the Civic Center near the Hall of Administration. The dedication took place around 1987. Standing in the center are Supervisor Roger Stanton (fourth from right) and Congressman Bob Dornan (third from right). Kneeling in front is Assemblyman Mickey Conroy. (Courtesy of the Orange County Archives.)

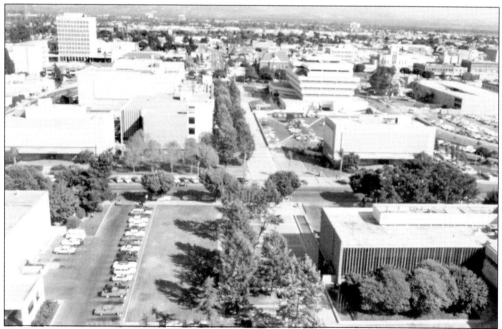

This aerial view of the Civic Center in 1980, looking east, shows that the area is now largely built out. The Santa Ana Public Library is in the left foreground. Slightly right of center is the county administrative building, with the Old Courthouse shown almost directly behind it and the Masonic Temple behind it to the right. (Courtesy of the Orange County Archives.)

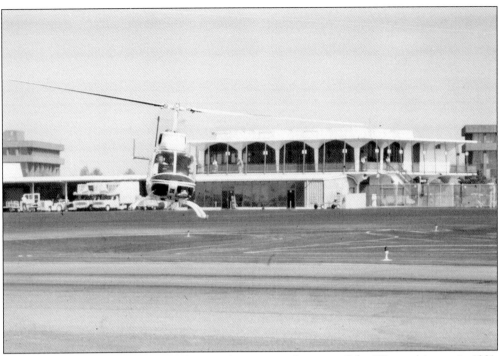
A helicopter takes off from Orange County Airport, now known as John Wayne Airport, in 1981. (Courtesy of the Orange County Archives.)

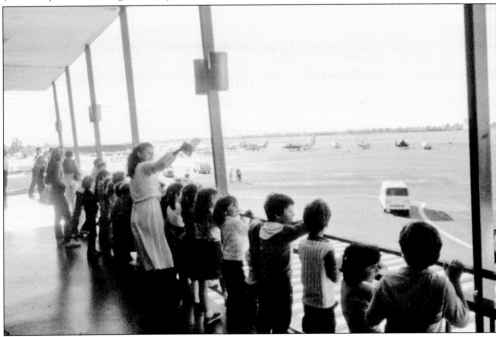
A group of schoolchildren tour the Orange County Airport during a field trip. They are able to watch the planes take off and land on an outdoor observation deck at the terminal. Back in 1981, at the time this picture was taken, boarding passes were not required to access the gate area of the terminal. (Courtesy of the Orange County Archives.)

Military personnel observe a solemn moment of reflection at the Vietnam Memorial in the Civic Center on Green Ribbon Day in July 1981. (Courtesy of the Orange County Archives.)

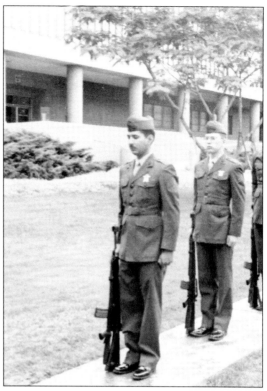

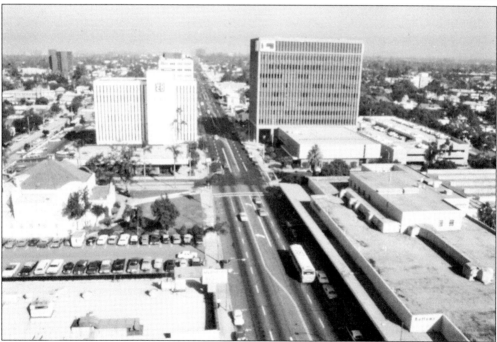

The Main Street Business District is pictured in the 1980s. Buffums' Department Store is in the foreground on the right. In the center left is the First Church of Christ, Scientist. (Courtesy of Rob Richardson.)

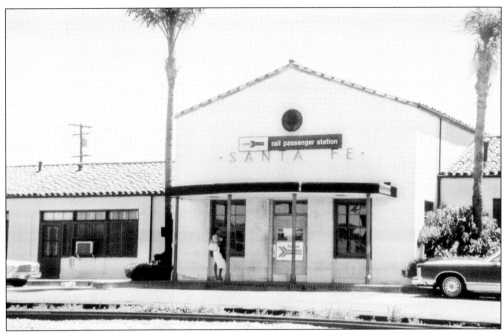

The Santa Ana Amtrak Station is pictured in the 1980s. In a few short years, this station would be replaced by the larger Santa Ana Regional Transportation Center, which would include Greyhound Bus service as well as Amtrak and eventually Metrolink commuter rail. (Courtesy of Rob Richardson.)

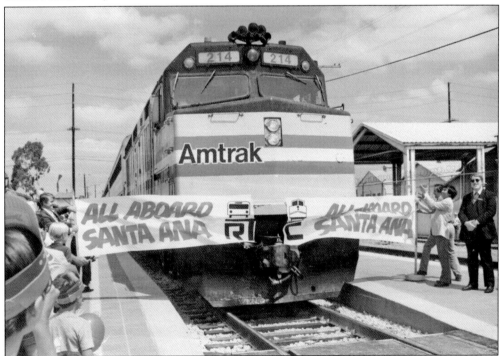

Amtrak's first trip into the new Santa Ana Regional Transportation Facility on opening day in 1985 is welcomed by an enthusiastic crowd. (Courtesy of Rob Richardson.)

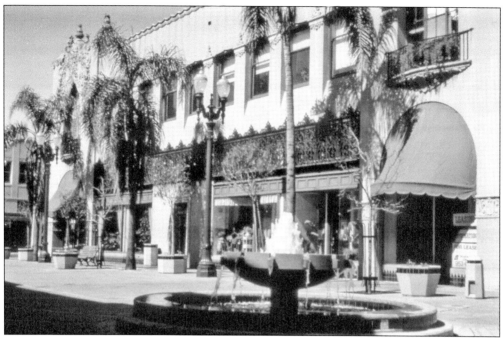
The Cherrigueresque-style Santora Building was built in 1929 by the Santora Land Company. The building was restored in the 1980s and is currently occupied by artists as part of the Artists' Village movement. On the south side of the building, shown in this photograph, Second Street was closed off and a walking mall with a fountain was created. (Courtesy of Rob Richardson.)

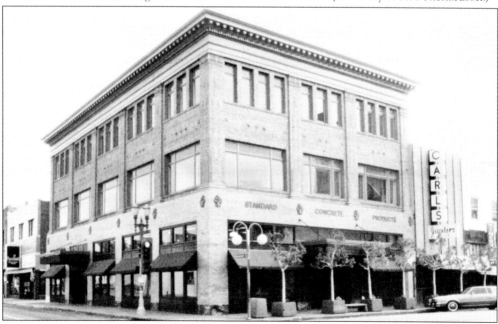
Formerly Rankin's Dry Goods at Fourth and Sycamore Streets, the store later became known as Jackman's after Rankin's closed. Shown here in 1982, the building was occupied by Standard Concrete Products. Tom Horowitz of Standard Concrete was active in the revitalization of downtown in the 1980s. (Courtesy of Rob Richardson.)

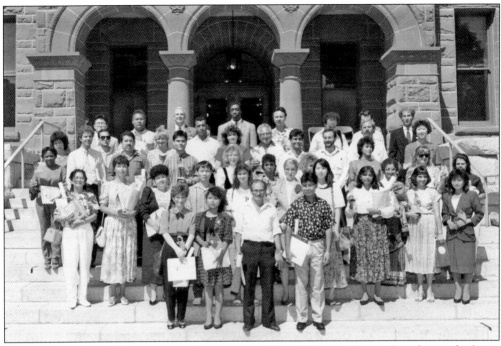
Another group of new U.S. citizens stands on the steps of the old Orange County Courthouse after being sworn in. This photograph was taken in 1987. (Courtesy of the Orange County Archives.)

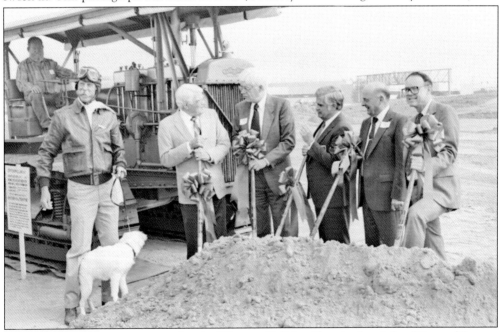
The ground-breaking ceremony for the Thomas F. Riley Terminal at John Wayne (Orange County) Airport took place in October 1988. Supervisor Riley is shown on the left, next to the unidentified aviator. The 337,900-square-foot facility with 14 loading bridges and four baggage carousels opened in 1990, replacing the aging Eddie Martin Terminal less than one-tenth its size. (Courtesy of the Orange County Archives.)

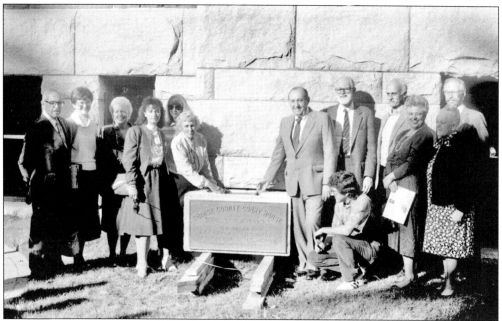

The Orange County Historical Commission poses with the new cornerstone at the Old Orange County Courthouse in December 1988. From left to right are (kneeling) a very young Phil Brigandi, future Orange County archivist; (standing) Lecil Slaback, Carol Jordan, Nancy Thatcher, Colleen McGregor, Judy Liebeck, Jane Gerber, Ron Novello of Orange County Environmental Management Agency, Bill Hoey, Keith Dixon, Esther Cramer, Don Dobmeier, and Elizabeth Schultz. (Courtesy of the Orange County Archives.)

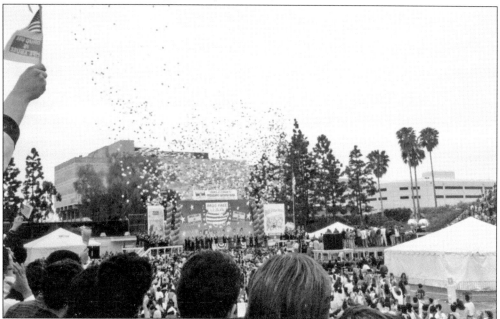

A spectacular balloon launch is staged at Eddie West Field on March 2, 1990, during an antidrug rally attended by Pres. George H. W. Bush. (Courtesy of the Santa Ana Public Library History Room.)

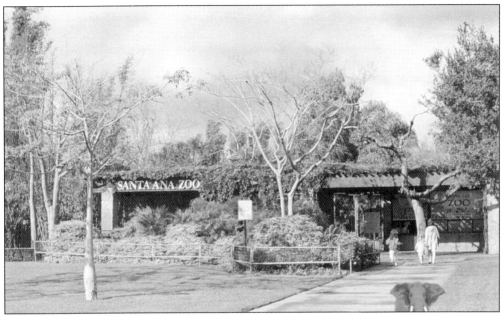

No longer just the Prentice Park Zoo, the Santa Ana Zoo in the 1990s has vastly expanded and has become a respected zoo in its own right. Over 270,000 visitors come to the zoo annually. (Courtesy of Nathan and Roberta Reed.)

In the early 1990s, Orange County began construction on two twin facilities at the corner of Flower Street and Santa Ana Boulevard to house growing operations of the Environmental Management Agency as well as the county coroner's office. The Environmental Management Agency building was named the Osborne Building after one of the agency's former directors. (Courtesy of County of Orange, Resources and Development Management Department.)

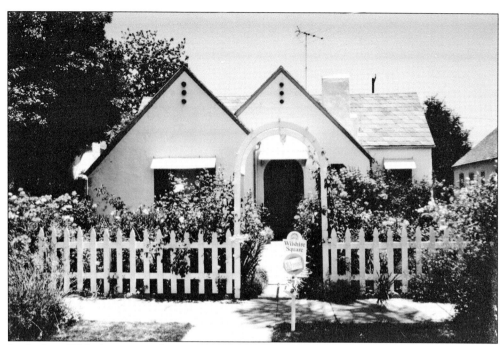

In the late 1980s, home tours became a popular way for neighborhoods to showcase their homes while at the same time raising funds for neighborhood projects. Wilshire Square Neighborhood was one of the first to conduct home tours. This home was featured as one of the popular garden stops during several home tours. (Courtesy of Nathan and Roberta Reed.)

The Santa Ana Historical Preservation Society celebrated its 25th anniversary in 1999. Connie Becker, one of the society's founding members, welcomes visitors in the entry of the restored Dr. Howe-Waffle House. Becker was delivered by Dr. Howe-Waffle. (Courtesy of Nathan and Roberta Reed.)

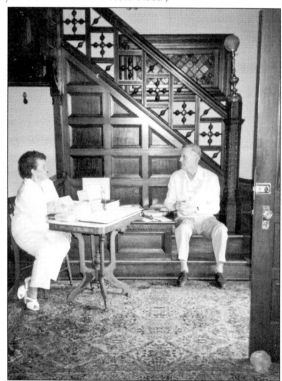

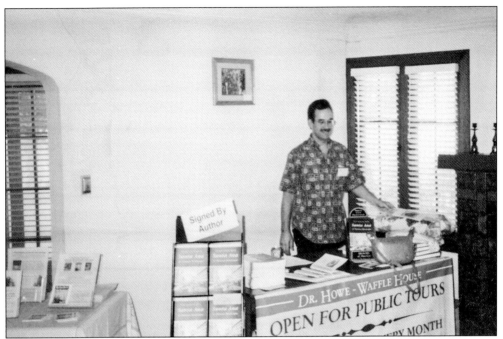

Arcadia author Guy D. Ball mans the Santa Ana Historical Preservation Society table and autographs *Santa Ana in Vintage Postcards* at the Wilshire Square Neighborhood 2001 Home Tour. (Courtesy of Nathan and Roberta Reed.)

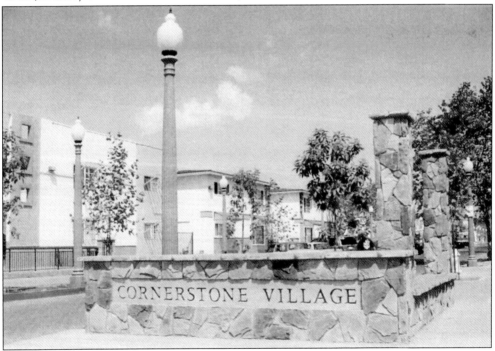

Cornerstone Village was created in 2002 when the city partnered with property owners in the Minnie Street area to redevelop it and improve living conditions for residents there. (Courtesy of Rob Richardson.)

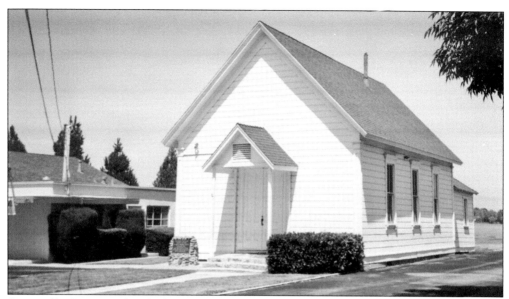

Greenville Country Church, located on Greenville Street just north of MacArthur Boulevard, was built in 1877 on land donated by William Tedford. Originally part of the Methodist Episcopal Church, South denomination, it is still meeting at the same location today, although a larger sanctuary was built next door in the 1960s. The church is shown here in 2002. (Photograph by Chris Jepsen; courtesy of the Orange County Archives.)

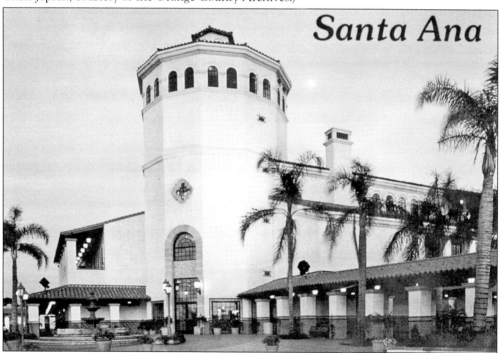

Built in 1985, the Santa Ana Regional Transportation Facility, pictured here around 2005, replaced the old Amtrak/Santa Fe Train Station at approximately the same site. The new facility accommodates Amtrak, Santa Fe (now Burlington Northern Santa Fe), and Metrolink, as well as Greyhound Bus service, all in the same location. (Courtesy of Nathan and Roberta Reed.)

The Santa Ana Historical Preservation Society has held annual cemetery tours at Fairhaven Memorial Park since 1998. The purpose of these tours is to educate the public regarding Santa Ana and Orange County history. These two photographs show students from the Orange County High School of Performing Arts at the 2002 Civil War–themed tour. The society won a 2007 Historic Preservation Award from the State of California for these tours. (Both photographs by and courtesy of Guy Ball.)

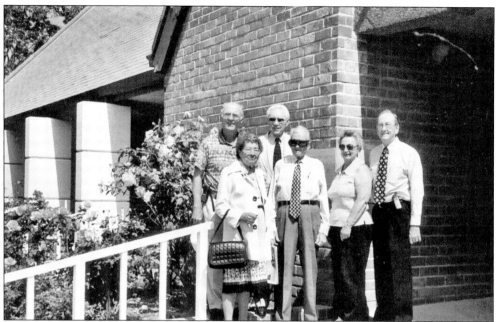

In 2002, members of the First Christian Church sold their property to Santa Ana College for its expansion. Prior to demolition of the sanctuary in 2003, members removed the time capsule from the cornerstone and opened it during a church service. In the top photograph, church members pose on the sanctuary steps in front of the time capsule before it is removed. From left to right are (first row) Katherine Lehman, Ed Lehman, Deloris Runnells, and Bob Kelly; (second row) unidentified and Elwyn Buche. In the bottom photograph, members pose prior to opening the time capsule. From left to right are George Anderson, Dorothy Hurd (whose husband, Nylin, constructed the church), Dan Lucas, Dean Pierce, unidentified, and Bob Runnells. (Both courtesy of Nathan and Roberta Reed.)

The stained-glass windows in the First Christian Church Chapel are seen before they were removed to protect them from demolition. The windows were donated to the Santa Ana Historical Preservation Society for protection, and the society in turn donated them to Hope University to be used in a new building expansion project. Hope University has had a long relationship with the church. These windows had been previously located in the church facility at Sixth and Broadway Streets. (Courtesy of Nathan and Roberta Reed.)

The Santa Ana Mounted Police educate and entertain at Santa Ana Historical Preservation Society's 2005 Cemetery Tour at Fairhaven Memorial Park. The theme was "OC Confidential: Law and Order in Early Orange County." (Courtesy of Guy Ball.)

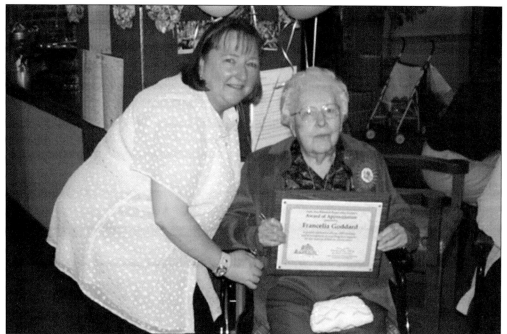
Santa Ana Historical Preservation Society president Alison Young presents a Certificate of Recognition to longtime resident and society member Francelia Goddard on her 100th birthday in 2007. Goddard has lived in Santa Ana for 74 years and was once the children's librarian at the Santa Ana Public Library. (Courtesy of Nathan and Roberta Reed.)

The historic French Park neighborhood celebrated Christmas 2007 with its biennial Christmas Home Tour on December 8 and 9, 2007. The neighborhood has a fine collection of Victorian and Craftsman homes, as this home, also the neighborhood winner of the 2007 City of Santa Ana Most Beautiful Yard Contest, shows. (Courtesy of Jeff and Ann Dickman.)

Discover Thousands of Local History Books Featuring Millions of Vintage Images

Arcadia Publishing, the leading local history publisher in the United States, is committed to making history accessible and meaningful through publishing books that celebrate and preserve the heritage of America's people and places.

Find more books like this at
www.arcadiapublishing.com

Search for your hometown history, your old stomping grounds, and even your favorite sports team.

Consistent with our mission to preserve history on a local level, this book was printed in South Carolina on American-made paper and manufactured entirely in the United States. Products carrying the accredited Forest Stewardship Council (FSC) label are printed on 100 percent FSC-certified paper.